Paper should be edible, nutritious. Inks used for printing
or writing should have delicious flavours. Magazines or
newspapers read at breakfast should be eaten for lunch.
Instead of throwing one's mail in the waste-basket, it should be
saved for the dinner guests.

John Cage, *M: Writings '67 - '72*, Henmar Press Inc., New York,
1973, p. 115.

Foreword

Dr Maria Balshaw, Director Manchester City Galleries and Whitworth Art Gallery

At the height of the Industrial Revolution the North West of England was a pioneering force in the industrialisation of the papermaking process, even exporting products and expertise to those countries where paper had originated, such as Japan. It is still one of the most important regions for the industry: it is home to the UK's largest paper mill, employs around one quarter of the UK's paper workforce and the paper industry in the North West is one of the most forward thinking industries in terms of recycling, energy conservation and the environment.

The 31 artists in *The First Cut* invite the viewer to radically re-think the possibilities of this basic material. Some hand-make their own paper from material such as seaweed and textile fibres, others use the detritus of the fast food industry, second hand books, vintage maps, currencies, basic office paper and, at the other end of the scale, high grade artist paper. In the hands of the artists this fragile material becomes a powerful means to articulate ideas and concepts that tackle issues as varied as globalisation, consumerism, geopolitical boundaries, the environment and race, as well as more personal concerns referencing depictions of the body, childhood and memory.

Truly global in reach, this exhibition features artists from America, Australia, Denmark, France, Germany, Italy, Japan, Sweden, Taiwan and the U.K., all working with paper in unique ways. We are delighted to be showing such a large body of new work, including seven large-scale new commissions and a number of other new artworks that have been created especially for *The First Cut*. Some artists have made work in response to the spaces at Manchester Art Gallery, which will be re-worked for our touring partner venues, Djanogly Art Gallery, Nottingham and Sea City Museum and Southampton City Art Gallery.

We have also included works that resonate with historic works from the Gallery's permanent collections: Susan Stockwell's interest in Imperial Britain is embodied

in *Colonial Dress*, set against the backdrop of late 18th and early 19th century works that were created during an era of exploration and travel that heralded Britain's dominance as a world power. Claire Brewster's *Apocalypse of Butterflies*, cut from vintage maps of the British Isles, draws on the pre-Raphaelite doctrine of truth to nature and has an affinity with the Victorian artist's vivid colour palette and the era's obsession with collecting and classifying the natural world. In *The Garden of Earthly Delights* Tom Gallant utilises a William Morris wallpaper design to camouflage pornographic imagery. This work sits alongside Spencer Stanhope's *Eve Tempted* in a gallery dominated by depictions of 'fatal women' that reflect late Victorian male fears as women campaigned for equal rights and new roles. In *The Calculation of Loss* Justine Smith's snowdrops, symbolic of death and re-birth, are fashioned from old pound notes and appear petrified in a glass dome amongst objects that mark out emotional milestones and life events in our Gallery of Craft & Design. The dresses and shoes created by Susan Cutts, Violise Lunn and Susan Stockwell respond to the historical costume displays and grandeur of the Georgian setting of the Gallery of Costume.

Our profound gratitude goes to all the artists whose artistic brilliance, hard work and trust have made the exhibition such a success. I would also like to thank my colleagues at Manchester Art Gallery whose vision, passion and diligence has led to the realisation of this extraordinary exhibition. Particular congratulations go to Fiona Corridan and Natasha Howes for their vision and dedication in bringing *The First Cut* into being. Such a large scale exhibition, with numerous new commissions and an extensive body of loans would not be possible without the support of a number of individuals, funding bodies and companies. We're incredibly grateful to Arts Council England North West, The Japan Foundation and The Henry Moore Foundation for their generous support. We have been supported locally by The Granada Foundation and law firm DAC Beachcroft, which has allowed us to launch a region-wide competition to encourage creativity amongst school pupils and university students across the North West. Dr Chris Klingenberg has supported the commission of a new work by Justine Smith for *The First Cut: Editions,* a venture that will offer visitors the chance to purchase limited edition work by artists in the exhibition. Roger la Borde have worked in partnership with the gallery to offer one lucky undergraduate the

opportunity to see their work realised as a nationally available greetings card and are generously donating proceeds raised from a set of specially commissioned artist cards to Manchester Art Gallery's Trust. We have the perfect partnership with GF Smith, one of the world's leading suppliers of specialist papers, who have provided the beautiful papers used in this publication, as well as for our promotional print, public workshops and selected artwork in the exhibition.

There are also a number of individuals and galleries whose advice and support has been invaluable during the research and production stage of this exhibition and we'd like to thank Dena Bagi and Kate Day at the Manchester Craft and Design Centre, Ana Cristea Gallery, Jane Crowther and Mark Jesset at GF Smith, Daniel Cutmore, Cindy Daignault, Mark Doyle at The Contemporary Art Society, Jane England of England & Co Gallery, Bruce Ferguson, Scott Fitzgerald, Ai Hayatsu, Caroline Hession at MSD Capital, L.P., Juan Hinojosa, Pippy Houldsworth Gallery, David Hoyland at Seventeen Gallery, Irene Langford at The Granada Foundation, Dan Matthews at Southampton Museum and Galleries, Robert Moss at DAC Beachcroft, Manabi Murata, Hazel Nichols, Alice O'Connor at The Henry Moore Foundation, Lora Reynolds Gallery, Kathy Richmond, Scai the Bathouse, Poppy Sebire Gallery, Alison and Tim Solnick and Jenni Barnet at Roger la Borde, TAG Fine Arts, Junko Takekawa at The Japan Foundation, Alan Ward, Neil Walker at Djanogly Art Gallery and Jessica Wild.

We are also indebted to the private and institutional lenders who have generously agreed to lend works from their collections, including Bob and Vicky Angus, Glenn and Amanda Fuhrman and FLAG Art Foundation, Jason and Sophia Hirsch, The Brontë Parsonage, Patrick Heide Contemporary Art, Tate and the Victoria & Albert Museum.

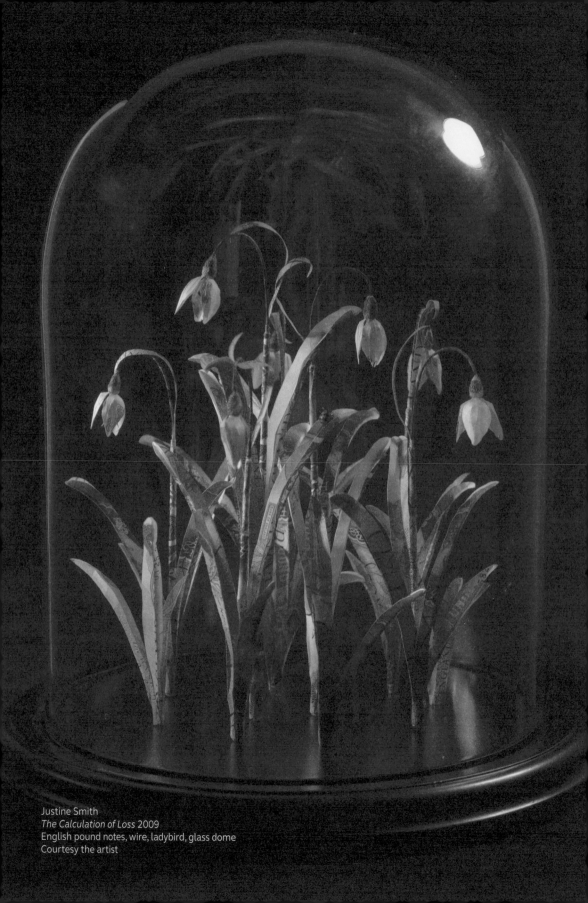

Justine Smith
The Calculation of Loss 2009
English pound notes, wire, ladybird, glass dome
Courtesy the artist

The Muse of Paper

Natasha Howes with Fiona Corridan

Paper, once a precious and rare commodity, is now a democratic material which is cheap, available and ubiquitous. We take paper for granted and, yet, in our environmentally conscious times, we are reminded of the need to reduce its consumption. The paperless office, a phrase which first appeared in print in 1975, never quite materialised, such is our fundamental need to document and keep records. In the face of the digital overload of emails, e-books and social networking, contemporary artists are returning to the handmade and revelling in the materiality of paper. Paper cutting is a solo and obsessive activity, which requires concentration and repetition. It can be a haven from the incessant mass communication of this impersonal electronic age.

The First Cut is an exhibition of 31 international artists who draw on paper cutting techniques to produce an extraordinary body of varied and beguiling work. It is not a survey show of paper artists but rather a selection of artists who challenge paper's capabilities. Paper is unique in combining fragility and strength, soft folds and sharp edges. Utilising manufactured and hand-made papers, books, magazines, paper bags, maps and money, artists are transforming a humble material into fantastical works of art with high levels of craftsmanship and meticulous detail. Whether it is two dimensional work, animation, sculptures or whole room installations, all the artists celebrate the potential of this material. We selected artists who work primarily with paper or who have an important body of paper cutting work within their practice. The artworks often blur the boundaries between art, craft and design, although most of the artists have a background in fine art. Without a need for expensive equipment, paper cutting can be produced with just a pencil, eraser and scalpel. At a time of economic austerity, the accessibility and immediacy

of paper as a material has democractic appeal. The manipulation of paper by hand leads to an intuitive physical connection with the medium. The tactility of paper is both a pleasure for the artist and the viewer.

The title *The First Cut* alludes to the initial action taken by each of the artists in the show, the beginning of the creative process that is open to all sorts of possibilities. It also suggests a violent action, with a razor-sharp knife making the cut, causing irreparable damage. The glint of the blade has a menacing threat and the action of slicing is almost surgical, wounding a pristine sheet of paper. The inherent fragility of the material means that a work could be destroyed with a single tear. Many of the artworks in the exhibition are imbued with sinister overtones and have various influences including globalisation, environmentalism, sexuality, slavery and death metal. The dark side of fairytales with menacing forests and childhood innocence in peril is a popular subject, often inspired by the tales of Hans Christian Andersen, who himself was a paper cutter and would entertain an audience with an evening of storytelling and paper cutting.

There are five thematic concepts around which the work is grouped. This is not intended to close down meanings of individual artworks but is a loose organisational principle within which to explore techniques, materials or ideas.

Imaginary Worlds
--

The first section looks at the creation of magical environments through site-specific artworks that explode from or spiral out of the gallery walls and unique walk-in installations. Visitors can peer into spiralling voids inspired by studies into the nature of our universe by Andrew Singleton or examine Mia Perlman's three dimensional interpretation of weather systems and cosmological cycles. Manabu Hangai's installation of 30 colourful trees made from handmade Japanese seaweed paper is a dramatic and enchanted forest, calling to mind fairytales but with a dark ecological message. These imaginary worlds are all large scale, experiential works which overwhelm the senses and spark the imagination.

A number of works play with our sense of space and time. Abigail Reynolds splices together photographs of the same view from different eras into a three dimensional "bulging time ruffle"[1] creating new landscapes which are out of time. Also taking architecture as her starting point, Laura Cooperman's sculptures of building layouts combine motion and engineering. The sense of movement is brought sharply to a stop by Chris Jones' almost petrified sculptures. Covered in hundreds of magazine images, Jones offers glimpses of worlds within worlds which are in the process of entropy and decomposition. Animals and flowers from the natural world are condensed into Andrea Mastrovito's geometrical garden on the gallery floor, with flowers at their peak of perfection but overrun by a plague of frogs. All these works play with notions of reality, artifice and time.

This theme also includes miniature imaginary worlds, requiring close examination and exploration. Explosive cut-out collages spring or spill out of matchboxes comprised of vintage ephemera composed by Sarah Bridgland. Yuken Teruya cuts delicate trees into fast food and luxury brand bags to create small, vulnerable dioramas which explore global consumerism and its environmental impact. Using white sheets of A4 paper, Peter Callesen creates deceptively simple scenes of drama, melancholy and humour, using economic means to capture a tense or poignant moment. Finally the tunnel books of Andrea Deszö depict unsettling scenes inspired by personal memories, folk stories and myths in mini stage sets. These diminutive scenes powerfully transport us into our own journeys of the imagination.

Drawing with a Knife

Drawing with a Knife features artists who use a scalpel like a pencil to create predominantly two dimensional artworks. Unlike painting which necessitates liquid materials and the adding of layer upon layer of paint, paper cutting requires few tools, a clean space and presents the almost paradoxical process

1 Abigail Reynolds in an email to Natasha Howes 30/7/2012.

of making art through taking away. Tom Gallant cuts into existing printed material, creating intricate patterns inspired by the designs of the Arts and Crafts movement. Using pornographic magazines, his works glow with the sensory colour of flesh, partly revealed, partly concealed and the absent male is strongly present.

The art of the silhouette became very popular in the 17th and 18th centuries as people commissioned their profile portraits to be made from black paper. During times of economic uncertainty, this was much more affordable than a painted portrait. Today Kara Walker employs this medium but uses complete figures who are engaged in often violent exchanges with each other in work which asks us to confront the racial, social and gender inequalities of the American South. Australian Emma van Leest creates incredibly intricate vignettes of figures within imagined topographies, inspired by European architecture and Eastern spiritualism. The depiction of figures within a landscape is taken further by Rob Ryan and Béatrice Coron. The signature papercuts of Rob Ryan combine the text and imagery of romantic dreams and conjure up thoughts of reverie, loneliness and longing. Dreams turn to nightmares in the hands of Béatrice Coron whose epic silhouettes evoke visions of urban chaos. Her fantastical landscapes are populated by hundreds of people going about their daily business in a dystopian vision. James Aldridge's silhouettes take a menacing turn with imagery of birds and skulls inspired by listening to heavy metal music. Fascinated by nature and living in a Swedish forest, Aldridge provides a corollary to an idealised and romantic view of the natural world.

Moving away from figurative work, Andreas Kocks cuts graphite coated paper which he layers to produce three dimensional, abstracted wall drawings. Kocks responds to the architecture of a space, making monumental works which inject fluidity and movement into white cube spaces. Here drawing with a knife becomes sculptural and the layers of cut paper extend off the wall.

Off the Page

Books are a significant source of inspiration. Artists who cut, deform, twist together and shred publications feature here, utilising different types of publications, from telephone directories to iconic books to pulp fiction. Long-Bin Chen and Nicola Dale are interested in the status of books in our digital age and both use discarded books, resurrecting and giving them new life. Once repositories of knowledge, now this information can be accessed by the click of a mouse, viewed as dusty detritus by our electronic society. Chen carves stacks of New York telephone directories into figures and busts, alluding to the transience of human knowledge. Dale has adorned a felled oak tree with thousands of leaves cut from reference books with each branch symbolising a branch of knowledge. She looks to the future to ask how will we record, store and archive knowledge. Another artist who employs second-hand books is Chris Kenny who collects and cuts out phrases which he categorises and reorders to produce surreal and humorous new texts. Meanwhile Georgia Russell shreds key books from the cannon of literature and art history, dissecting and reconstructing them before placing them in specimen jars to be preserved for future generations.

The content of books inspires Noriko Ambe, Su Blackwell and Andersen M Studio. Ambe cuts into artists' monographs, using her knowledge and understanding of the artist's work to dissect their images with organic contour cuts. Blackwell's sculptures are incised into an open book, illustrating a scene from the narrative in three dimensions. She is drawn to fairy tales and folklore and expresses the fears and imagination of childhood. The design practice Andersen M Studio has created award winning stop frame animations, including *Go West* based on a novel by New Zealand author Maurice Gee which literally brings the book to life as houses and trees spring up alongside a railway track. In this section mental imagery from stories is given three dimensional form with detailed figures and landscapes which spill off the page and, in the case of the final few frames by Andersen M Studio, walk off the page entirely.

Mapping New Territories

Artists that re-use maps, atlases and currency are the focus here. Maps are evocative of journeys, to real locations, to times gone by and to imagined places. There is a certain fiction to cartography – roads are not, in reality, coloured yellow and red, buildings are not pink and the actual landscape is not dotted with symbols like PH.[2] However we put our faith in maps to get us from A to B. Artists are not only drawn to their pastel colours but also to the linear illustration of their land formations. Susan Stockwell has used Ordnance Survey and world maps to create dresses. The contours of Scottish land masses in *Highland Dress* 2010 mirror the curves of the body and the world maps used in *Colonial Dress* 2008 are a commentary on the politics of exploration and imperialism.

Vintage maps hold a particular appeal in their subdued colouring and reminder of bygone travels. They chart how landscapes and political boundaries change over time and are resonant of past journeys and places lost to the passage of time. Whilst maps define boundaries, Claire Brewster's flocks of birds are immune to these controls as they swoop and swarm into the furthest reaches of the gallery spaces. Elisabeth Lecourt has also used historic maps and her children's dresses are fashioned from the most lavishly illustrated street layouts of Paris and New York for example. Using 1970s Ordnance Survey maps, Nicola Dale hand cut 12,000 individual feathers which sit in a mound, a quiet monument to journeys now consigned only to memories.

When mapping landscapes, Cartographers attempt to represent the natural and built world pictorially. Chris Kenny cuts out graphic representations of roads, landmarks, lakes and parks which he arranges according to shape and colour. Pinned like natural history specimens, they form large circles and the unlikely juxtapositions build a landscape of the imagination and make it impossible to find one's way. Noriko Ambe's eroded landscapes resemble a 3D

2 The Ordnance Survey symbol for Public House.

slice of the contours of a map. Fabricated from individually hand-cut sheets of white paper, these non-existent places are an emotional geography of human sentiments and nuances.

Maps and international bank notes allow artists to examine political issues of borders, belief systems and power. Georgia Russell cut a map of England from an atlas only to discover that on the reverse was a map of Iraq. Her action preceded the invasion of that country by the coalition Western powers by three weeks. The fight for control of countries and borders is just as significant as it ever was. Currency is also imbued with connotations of power, dominant ideologies and control. In her money maps, Justine Smith represents each country by small denominations of their currency, revealing the exquisite illustrations depicted on the bank notes. These artists demonstrate that mapping and value systems have critical relationship with global politics.

Papering the Body

The final theme of the exhibition is *Papering the Body*. The Gallery of Costume, located in the 18th century Platt Hall, features artists who create dresses and shoes from paper. Susan Stockwell's dresses from maps and money are showcased here while Susan Cutts uses her own handmade paper to fashion her dancer's outfit. Violese Lunn reveals the traces of a spine or organs inside her crumpled and ethereal outfits, positioned in a stuccoed interior alongside historic portraits of women. These unwearable garments all explore identity in different ways. Unlike a protective carapace, they resemble a ghostly skin, leaving a strong echo of the absent female body.

The diversity of artworks in *The First Cut* showcases the versatility and unpredictability of paper. From large scale, show stopping installations to miniature sculptures, the 31 international artists are committed to taking paper beyond its natural boundaries. By transforming books, magazines and maps, using silhouettes, creating dresses, sculptures and installations, the artists demonstrate the huge potential and power of such a humble material.

What kind of act is it to cut through a surface? Potentially savage, vicious and even violent, it could also be a kind of surgery or suture – a sign of healing and reparation to come. A cut is the way we speak of discharging someone – we cut them out or cut them deeply – a social metaphor based on a knife's sharp line – the knife's social sharpness that ruthlessly stabs in the back. But a cut is also a break, a release, a change, a sudden movement that is transformative – metamorphasizing from one state to another, the cut that stitches time and images in movies – the cut that binds by being the cut that releases and frees. The difference that is the remove of courage. But always the edge is central, the edge of one thing and the space that inhabits the difference between two planes, two levels. It scores, it engraves, it incises, it precises…

Bruce W Ferguson, 'Outside of Sculpture, Outside of Drawing and Outside of Time' in *Andreas Kocks: Unframed – Paperworks*, Jeannie Freilich Contemporary, New York, 2007.

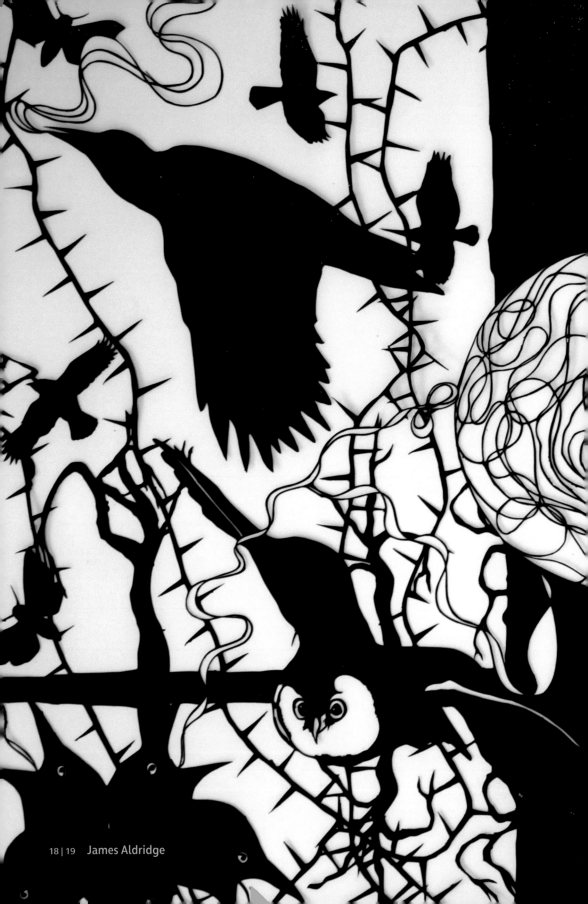

James Aldridge

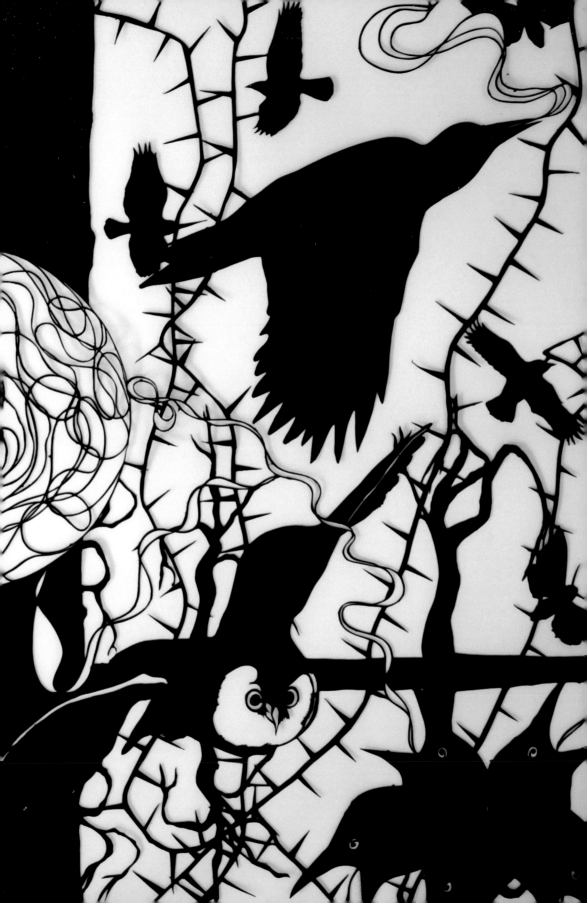

James Aldridge

James Aldridge's paper-cuts are stark and precise; a combination of the romance and eeriness of Victorian-era silhouettes with a contemporary graphic sensibility. Aldridge draws on a wide range of influences from natural history to heavy metal and explores concepts of knowledge versus belief and good versus evil. Living in the forest of Småland, southern Sweden, his work is not only influenced by this environment but also by the soundtrack in his studio of black metal. He explains "the rich visual language it employs is important to my work and by borrowing recurring symbols and images from this genre I re-position them, finding an edge where these elements can suggest something more mysterious and free of irony."[1]

This imagery features recurring motifs, including pagan symbols, spider webs, skulls, wolves, ravens and other birds. Aldridge's interest in birds stems from his childhood and he perceives the systematic identification in field guides to be at odds with a more romantic way of relating to the natural world. He says "the formality of a more structured approach to looking, along with the need to relate to the natural world through, for example, folklore informs the visual world I create."[2]

Aldridge has created a new large scale installation *As above, so below* 2012 for *The First Cut*. "Instead of adding lines, I eliminate the space. The negative spaces around the shapes are removed to reveal an image, so the outcome is never completely known. I make panels that all fit together. Because of their size and fragility, I never know how they are going to look until they are installed. I have to have a very clear mental picture of how the image is evolving."[3]

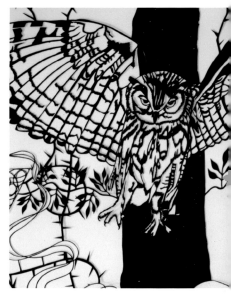

As above, so below (detail) 2012
Arches Velin paper 400gr
Courtesy the artist and Poppy Sebire Gallery

1 James Aldridge in an email to Fiona Corridan 01/08/2012.
2 Ibid.
3 Ibid.

←
As above, so below (detail) 2012
Arches Velin paper 400gr
Courtesy the artist and Poppy Sebire Gallery

James Aldridge was born in 1971. Following his graduation from Manchester Metropolitan University and the Royal College of Art, London, he was awarded a Fine Art scholarship at the British School in Rome. Aldridge's recent solo exhibitions, include Galería Casado Santapau, Madrid; *Bloodlines*, Poppy Sebire, London; *Unnatural Order*, Gabriel Rolt, Amsterdam and in 2013 at David Risley Gallery, Copenhagen.

Noriko Ambe

An important strand of Noriko Ambe's practice is her *Artist Book Project*. She bought monographs of significant artists' work and after gaining an understanding and respect for each artists' oeuvre, she decided on a theme to express, which then became part of the title. Seeing herself as a filter during the cutting process, she found points of intersection and conflict, emphasising the essence of the artist – a process which she viewed as a collaboration. She says "I have cut and chipped away other artist's works, dissecting the work and transforming it through the filter of my interpretation…. (it is) an offering to the god of art."[1]

The eroded landscapes in the series *A Piece of Flat Globe* sit at the interface between physical and emotional geography. Ambe cuts everything by hand, not interested in perfect, mechanical-looking lines but in subtle natural distortions which convey the nuances of human emotions, habits or biorhythms. She enjoys the work's changing shape as it develops, stressing the process of creating as equally important to the finished work.[2] The accumulation of cuts resembles contours on a map which Ambe describes as "another geography"[3] and sees similarities in her process to how humans interact with their restricted environment. For the *Artist Book Project* she cut from the back of each page so that she didn't know what kind of image would appear. She continues to cut away and leave behind until the book is on the verge of destruction, and then following her theme, she reconstructs it.

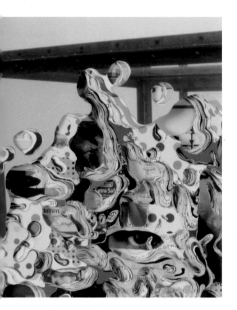

Art Victims: Cutting Book Series with Damien Hirst (detail) 2009
Cut book in plexiglass case
Collection Glenn and Amanda Fuhrman New York
Courtesy the artist and FLAG Art Foundation
Photo: Robert Boland

Noriko Ambe was born in Saitama, Japan, 1967. She studied at Musashino Art University, Tokyo and lives and works in New York and Tokyo. Her solo exhibitions include Syracuse, New York, Tokyo, Austin, Texas and New York and she has participated in many international group exhibitions. She has won awards from The Pollock-Krasner Foundation, New York and AICA Award and completed residencies and fellowships with Art Omi, USA, Japanese Government Overseas Study Programme for Artists and Freeman Fellowship, New York. Her work is represented in the collections of The Museum of Modern Art, New York, Whitney Museum of American Art, New York and K.K. R Collection, Tokyo.

1 Noriko Ambe, www.norikoambe.com/texts/artiststatement.html [accessed July 2012].
2 Ibid.
3 The artist, quoted in *Slash: Paper under the knife*, Museum of Art and Design, 2009, p . 52.

→
Art Victims: Cutting Book Series with Damien Hirst (detail) 2009
Cut book in plexiglass case
Collection Glenn and Amanda Fuhrman New York
Courtesy the artist and FLAG Art Foundation
Photo: Robert Boland

A Piece of Flat Globe Vol 8., (detail) 2008
Cut on Yupo and glue
Private Collection
Photo: Courtesy the artist

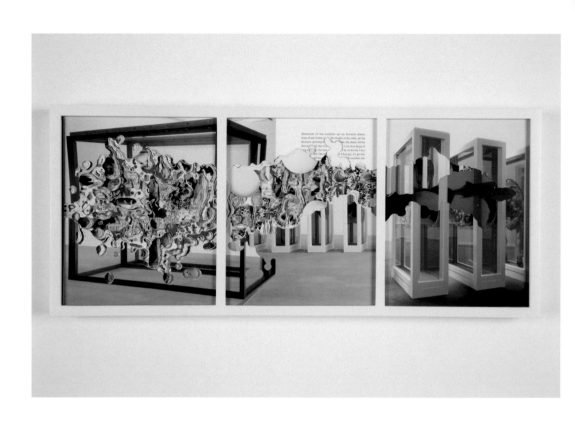

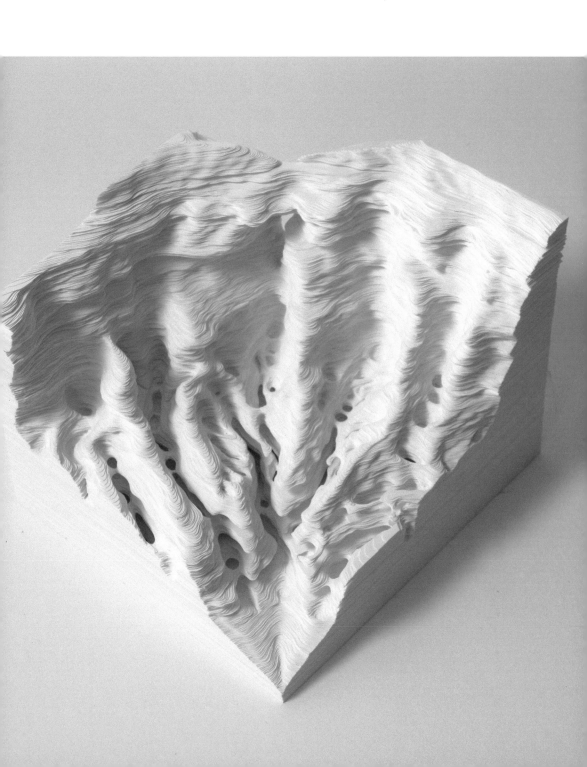

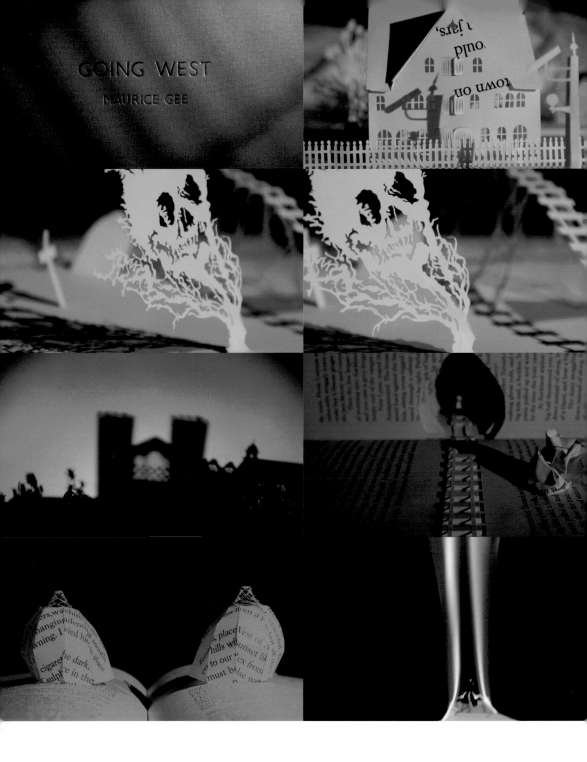

Andersen M Studio

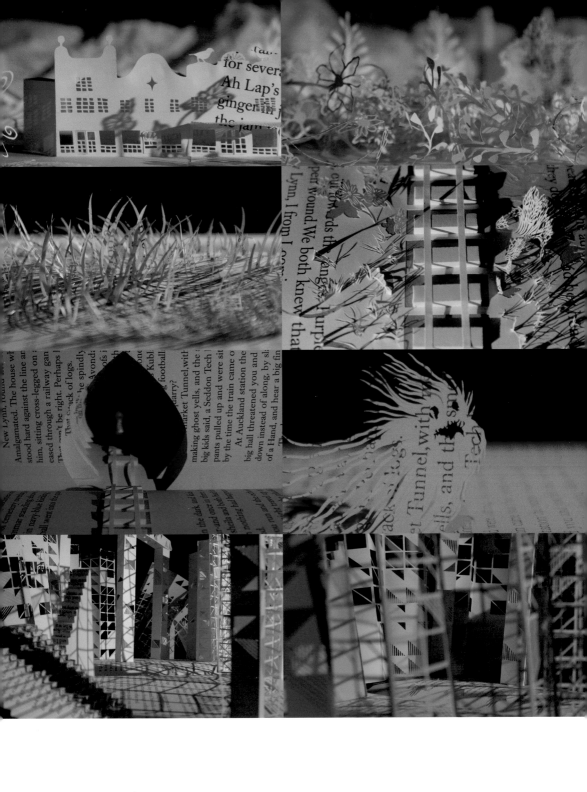

Andersen M Studio

Andersen M Studio is a creative duo made up of siblings Martin and Line Andersen. They work across a variety of creative practice, including art direction, graphic design, photography, animation, film and music.

Going West is an award-winning[1] stop-frame animation that was commissioned by Colenso BBDO for the New Zealand Book Council, who invited the duo to inspire people through the power of the written word. Andersen M brought to life a novel by one of New Zealand's most revered authors, Maurice Gee, in a two minute long animation that was used as a cinema commercial and piece of viral marketing. The animation took eight months to complete. They researched the environment described by Gee in the novel, before creating a handmade oversized bound book, from which Line painstakingly hand-cut individual scenes. Martin Andersen explains "everything is cut with a scalpel and we used two different cameras to photograph the animation. We both appreciate handmade aesthetics and enjoy the challenge of how to make things work on camera rather than in the editing stage. Examples such as the colour changes inside and outside the tunnel are all lit with coloured filters rather than adding the colour digitally later. We were convinced that it was worth doing it all manually to create the atmosphere we wanted to achieve."[2]

1 Awards include Gold for *Animation in Film Craft*, Cannes Lions 2010, France; *Grand Prize Award Moving Paper* 2010, Museum of Art and Design, New York; *Best Animation*, TV & Cinema Crafts, D&AD Awards 2010, UK.
2 Martin Andersen in an email to Fiona Corridan 06/08/2012.

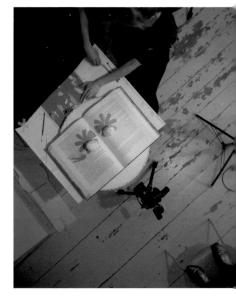

Andersen M Studio
At work in the studio 2012
Courtesy the artists

←
Going West 2009
DVD Stop Frame Animation
Courtesy the artists

Martin and Line Andersen were born in Denmark, but live and work in London. Martin Andersen studied at Ravensbourne College of Design and Communication and the Royal College of Art, London before working at V23 with renowned designer Vaughan Oliver, the creative force behind the iconic imagery of the 4AD music label. He is currently Senior Lecturer in Graphic Design at The University of Brighton and Associate Lecturer at Central Saint Martins College of Art & Design and School of Fashion. Line Andersen studied at Design Skolen Kolding, Denmark and Central Saint Martins College of Art and Design, London. As Andersen M, the duo create and deliver projects for a diverse range of clients, including BBDO, Channel 4, Publicis London, Southbank Centre and Sony.

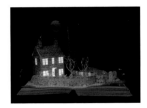

Su Blackwell

Su Blackwell gives form to the images we imagine when we read literature. She cuts out imagery from books to create three dimensional tableaux which are then placed inside display boxes. Fairy tales and folklore are rich subjects for Blackwell who is often drawn to the figure of a lone girl, in a vulnerable setting like a forest, expressing the wonders and fears of childhood. Choosing characters that are in flight or on the verge of discovering something adds urgency and potential to the scenes. Often a small light source illuminates the diorama, creating shadows which add to the psychological intensity of the scene.

Although Blackwell has been inspired by Lewis Carroll, Hans Christian Andersen and Frances Hodgson Burnett, she does not exclusively use children's books. In the work *Wuthering Heights* 2010 she presents her interpretation of the remote and romantic moorland farmhouse of the title.

After selecting and reading a book, Blackwell begins to cut out with a scalpel, paying special attention to the details which create drama and atmosphere. Using the page on which the narrative takes place, she painstakingly builds up the scene to bring the imaginary landscape to life. She says "I employ this delicate, accessible medium and use irreversible, destructive processes to reflect on the precariousness of the world we inhabit and the fragility of our life, dreams and ambitions."[1]

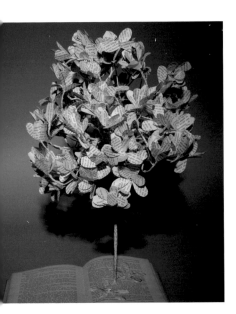

Magnolia Tree (The Story Tree) (detail) 2006
Handcut 3D book sculpture
Courtesy the artist

1 Su Blackwell, www.sublackwell.co.uk/profile/ [accessed July 2012].

Su Blackwell was born in Sheffield in 1975, studied at the Royal College of Art, London and lives and works in London. She has had solo exhibitions in New York, London and Edinburgh and participated in international group exhibitions. She has designed a theatre set for *The Snow Queen*, Rose Theatre, Kingston-on-Thames and is working on a children's book *The Fairy Tale Princess* to be published in October 2012 by Thames and Hudson. Her work is in the collections of Museums Sheffield and The Brontë Parsonage Museum, Haworth, Yorkshire. She has been commissioned by many clients including British Airways, The Guardian and Harvey Nichols.

→
Wuthering Heights 2010
Handcut 3D book sculpture
Courtesy the artist and The Brontë Parsonage Museum

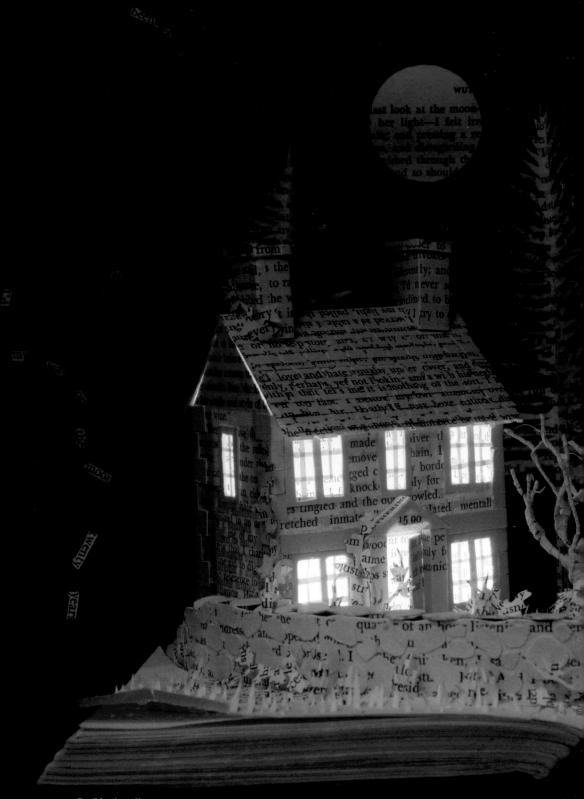

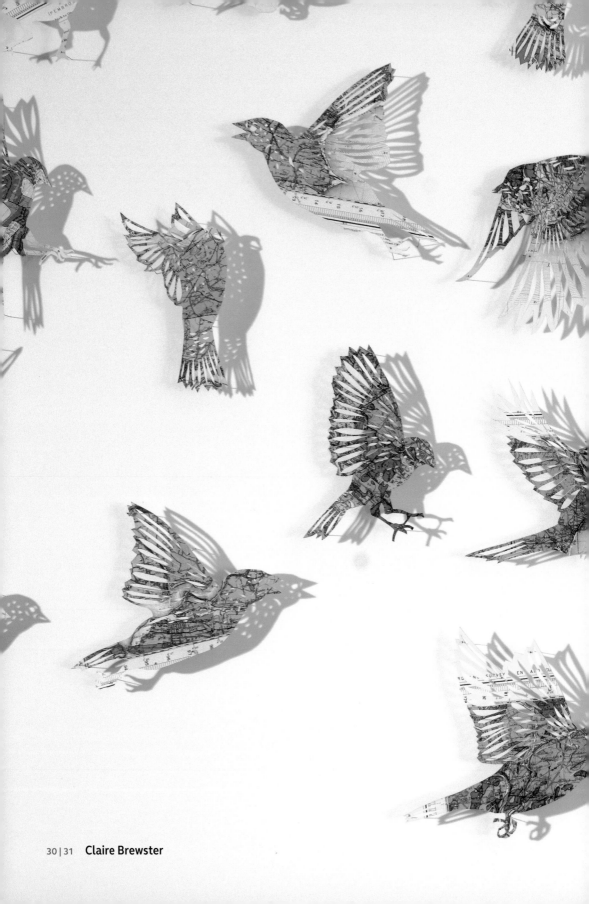

Claire Brewster

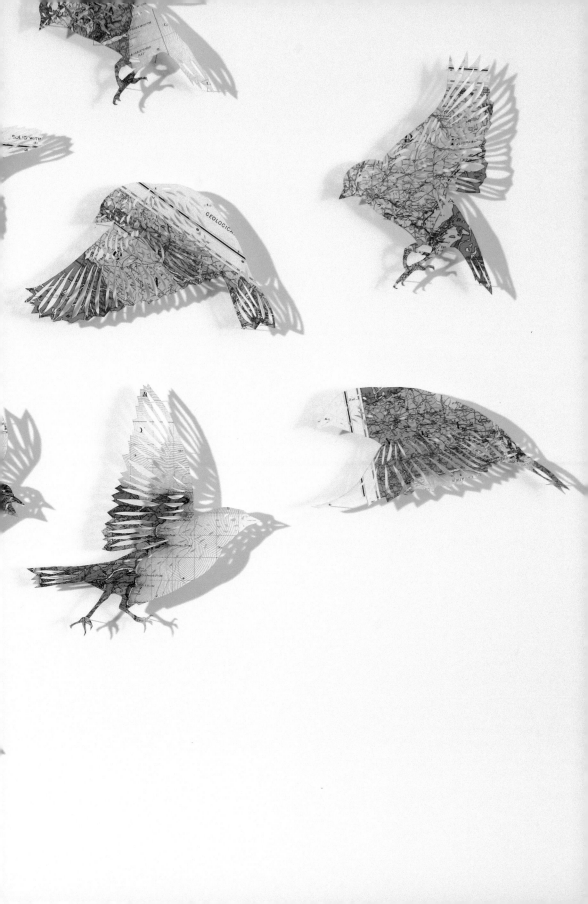

Claire Brewster

Claire Brewster creates flocks of birds and swarms of insects that are intricately cut from vintage maps and atlases. Common garden birds and native insects are rendered exotic through the colours and patterns inherent in her source material. Brewster appreciates the beauty of old maps and the quality of the material onto which they are printed: the aesthetic of maps imbues even the most run down of urban environments with beauty. Brewster is also interested in the way that wildlife exists and thrives in the unlikeliest of environments and how these creatures live alongside humans. Mankind uses maps to define and represent boundaries to control the way we represent and move around world, but the creatures that Brewster represents in her delicate papercuts exist outside of this control. They are affected by our actions yet unconscious of them. "My birds, insects and flowers transcend borders and pass freely between countries with scant regard for rules of immigration or the effects of biodiversity."[1]

Brewster pins her birds and insects to the wall in the manner of entomological specimens. However, she also draws on her interest in contemporary dance to create a sense of movement and dynamism in her installations, with the birds often frozen in attack mode.

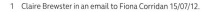

1 Claire Brewster in an email to Fiona Corridan 15/07/12.

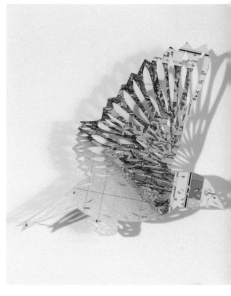

The Harbingers (detail) 2011
Hand-cut geological maps, pins
Courtesy the artist and TAG Fine Arts
Photo: Paul Minyo

←
The Harbingers (detail) 2011
Hand-cut geological maps, pins
Courtesy the artist and TAG Fine Arts
Photo: Paul Minyo

Claire Brewster grew up in Lincolnshire, studied Textiles and Fashion at Middlesex University and lives and works in London. Brewster's work has featured in numerous group exhibitions, most recently *Mind the Map*, London Transport Museum and *Ghost of Gone Birds*, a project involving 80 contributors, including Sir Peter Blake, Billy Childish and Margaret Atwood. She is also featured in a number of publications including *Paper: Tear, Fold, Rip, Crease, Cut* (Black Dog Publishing).

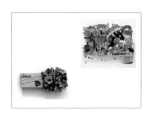

Sarah Bridgland

Sarah Bridgland's cut outs are like three-dimensional drawings with huge visual impact. Her exploding matchboxes and sculptures are created from second-hand ephemera collected from junk shops and fragments of her own printed media. She cuts out imagery and lettering and meticulously positions them into lively compositions, balancing the textures, colours, graphics and typefaces. They are at once playful and also highly influenced by the formal concerns of Russian Constructivism which favoured abstraction, modernity and geometry.

Inspired by the paper engineering of children's pop-up books and toy theatres, Bridgland is interested in the potential to create make-believe worlds. She constructs spaces where unrelated things come together in a seemingly chance meeting, a place where fact and fiction collide. She is drawn to a particular style of printed material, graphic images and typefaces redolent of 1950s design, evoking nostalgia, melancholia and a sense of a lost past. Bridgland reconstructs histories, exploring the links between object and memory, inviting the viewer "to re-experience the past in an entirely new way – half real, half imagined."[1] The intimate scale of her work encourages daydream and reverie, heightened by wonder at its meticulous craftsmanship.

1 Sarah Bridgland, www.sarahbridgland.com/bio.html [accessed July 2012].

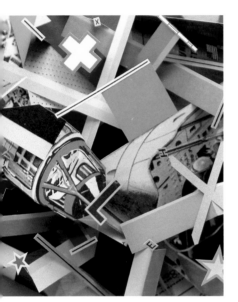

The 1970 World Almanac and Book of Facts
(detail) 2012
Paper, balsa wood, glue, acrylic paint
Courtesy the artist and Patrick Heide
Contemporary Art

Sarah Bridgland was born in 1982 in Cambridge and currently lives and works in the Peak District. She studied at the Royal College of Art, London and on graduating was selected for *Bloomberg New Contemporaries* 2006. She had her first solo exhibition in London in 2009 and has participated in many group shows worldwide. Her work is in the collections of the Philbrook Museum of Art, USA, The London Clinic and Sir Terence Conran.

→
Fotoecken 2012
Found German photo corner mounts box, paper card, glue
Courtesy the artist

The Pier 2012
Paper, card, balsa wood, glue, thread, pencil, paint
Courtesy the artist

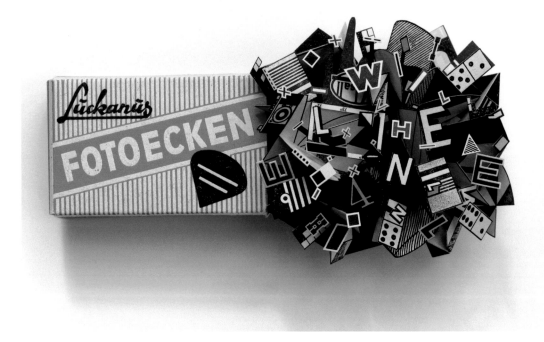

Sarah Bridgland

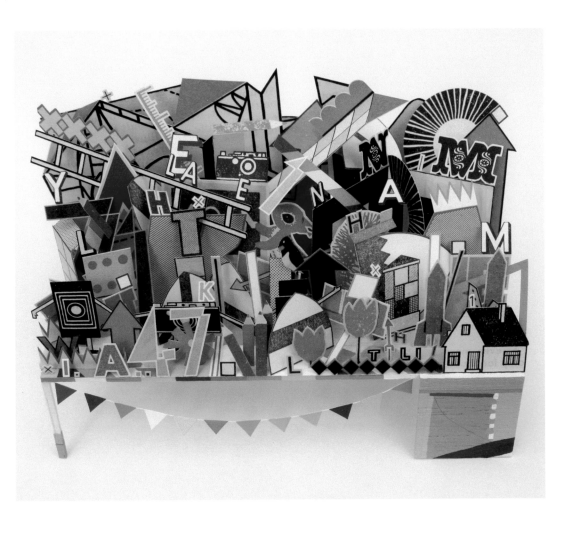

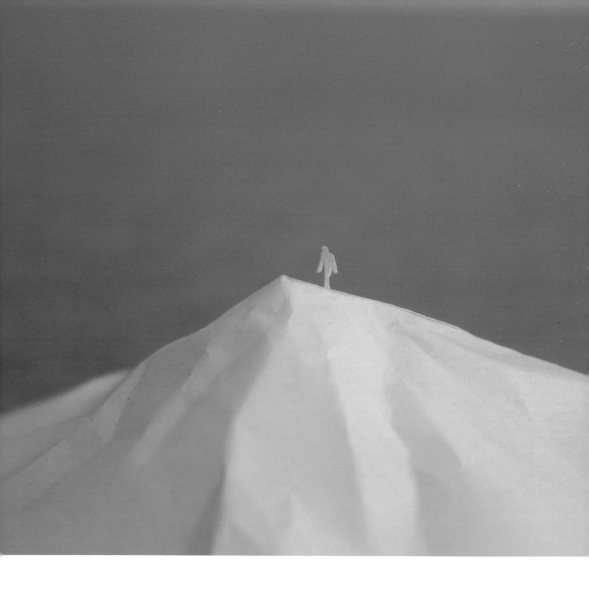

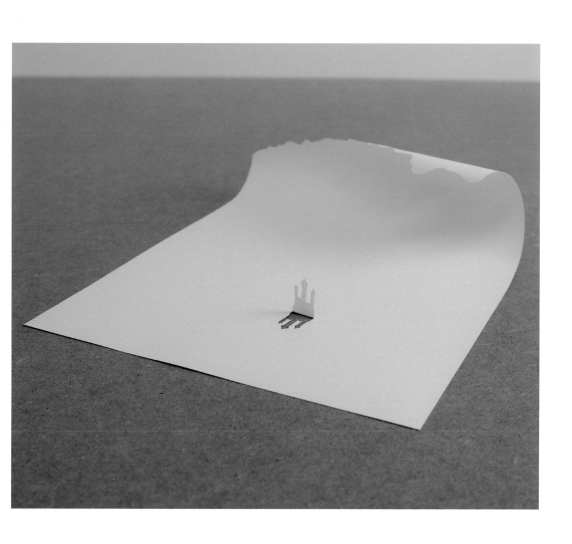

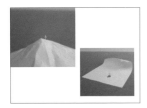

Peter Callesen

Peter Callesen often uses a single blank sheet of paper as a starting point for his simple but expressive scenes that are infused with drama, romance, melancholy and humour. In Callesen's hands a sheet of A4, a humble material that is fed daily through photocopiers and printers in our offices, becomes a pure material that offers a world of possibilities. He skilfully cuts three dimensional scenes, transforming the two dimensional surface into moments that appear frozen in time, such as a big wave moving towards a sandcastle or a solitary figure on a mountain top. Callesen explains his use of white A4 as "probably the most common and consumed media used for carrying information today, but we rarely notice the actual materiality of the A4 paper. It is perhaps as close to nothing as you can get. Using this 'worthless' material gives me as an artist a greater freedom to deal with heavy subjects and to fill the paper with more dramatic stories."[1]

The works could be destroyed with a single tear and the use of such a fragile material resonates with the vulnerability of the figures in the scenes Callesen creates. It is also often the negative image knifed out of the flat sheet that is the most poignant or expressive element of his work. Curator Anni Nørskov Mørch clarifies "whereas the three-dimensional picture is the technically sensational one, the negative picture appears more laden as far as meaning goes, which makes the absent statement become the more present statement."[2]

1 Peter Callesen, touring exhibition publication *Out of Nothing*, Tusculanum, 2009.
2 From *Peter Callesen: Contemporary Artist with a Romantic Spirit*, Anni Nørskov Mørch, www.petercallesen.com [accessed August 2012].

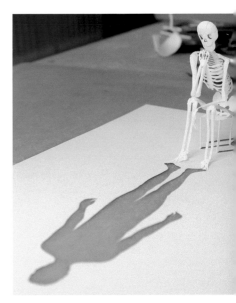

Looking back (detail) 2006
Acid free A4 80 gsm paper and glue
Courtesy the artist

←
Mountain II (detail) 2005
Acid free A4 80 gsm paper and glue
Courtesy the artist

Big wave moving towards a small castle made of sand 2005
Acid free A4 80 gsm paper and glue
Courtesy the artist

Peter Callesen was born in 1967 in Denmark and lives and works in Copenhagen. He studied at the Jutland Academy of Fine Arts, Aarhus and at Goldsmiths College, London. His recent solo exhibition *Out of Nothing* toured to four venues in Norway, Sweden and Denmark. International projects include *Mobile Journey*, a performance project for the 52nd Venice Biennale; Shanghai Biennale, Shanghai Art Museum, China, The Armory Show, New York, U.S.A. and Barcelona Arte Contempereano, Barcelona, Spain. In 2010 he was awarded The Royal Danish Academy of Fine Arts' Eckersberg Medal.

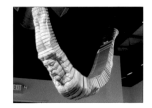

Long-Bin Chen

In our increasingly digital world, Long-Bin Chen is fascinated by analogue forms of information repositories. He terms out-of-date telephone books, newspapers, magazines and discarded books "the cultural debris of our information society."[1] Chen is particularly drawn to the valuable information in the New York phone book which, along with books, is now rendered obsolete in the face of social networking, email, Kindles and Skype. Shocked by how many books are discarded, Chen succeeds in giving them new life, recycling them into valuable and meaningful creations.

Using carpenters tools, Chen carves stacks of printed matter into monumental busts and figures. These heads are remarkably life-like and often specific portraits. From a distance they resemble wood or marble but on close inspection can be seen to be constituted from soft, light paper which could be leafed through. Viewers can still read the paper, and the sculptures are appropriate to the content of the publications.

Twist Angel 6 2011 is an arched, life-size human figure suspended from the ceiling. Here books are strung together with the spines facing up and the carved surface underneath. Cultural context is central to Chen's work, blending East and West, sculpture and literature. His work alludes to the transience of human knowledge and references the spiritual world. He has made many works about Buddha and his flying Angels further explore his interest in religion, communication and cultural difference.

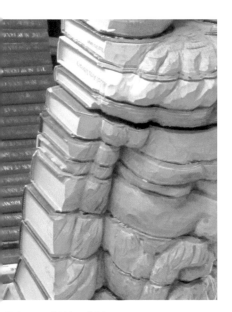

Twist Angel 6 (detail) 2011
Hand cut books, wire
Courtesy the artist

Long-Bin Chen was born in Taipei, Taiwan in 1964 and lives and works in New York. He studied at Tung-Hai University, Taiwan and the School of Visual Arts, New York. He has exhibited widely in the United States, London, Germany, France, Taiwan, Japan, and Hong Kong including Holland Paper Biennial, 2008 and *Second Lives: Remixing the Ordinary*, Museum of Art and Design, New York, 2008. Chen has been awarded many prizes, including the Grant of the National Endowment for Arts, Taiwan and The Silver Prize of Osaka Triennial (Sculpture), Osaka, Japan.

1 Long-Bin Chen in an email to Natasha Howes 24/07/2012.

→
Twist Angel 6 2011
Hand cut books, wire
Courtesy the artist

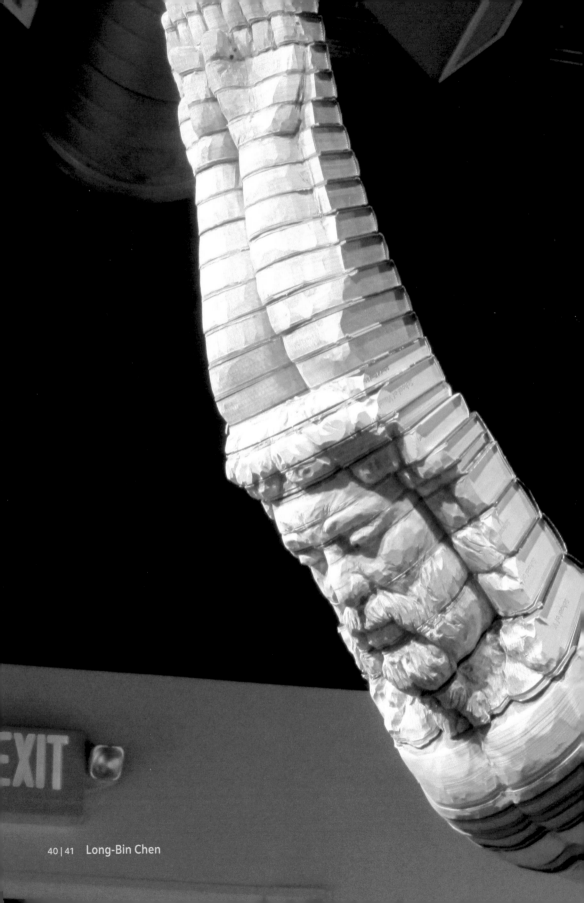

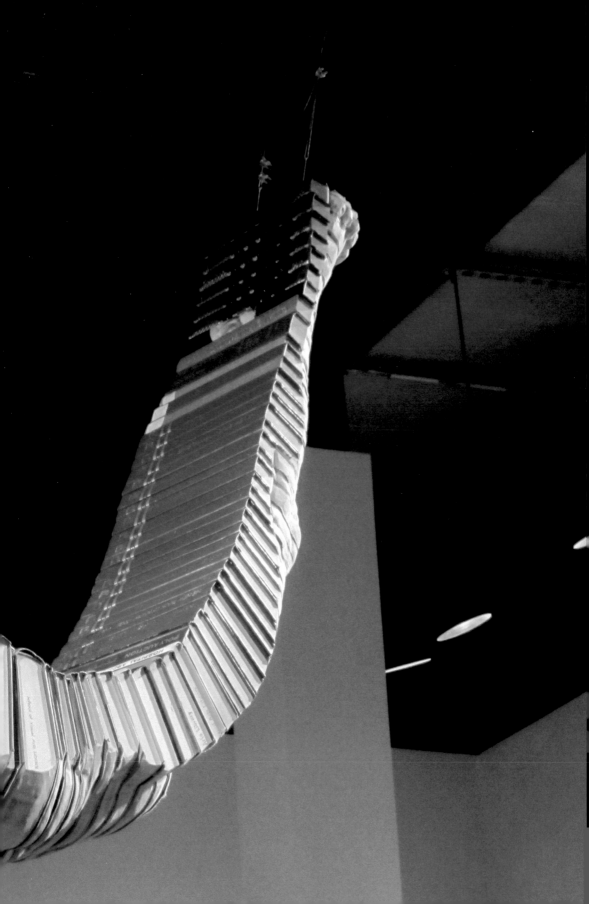

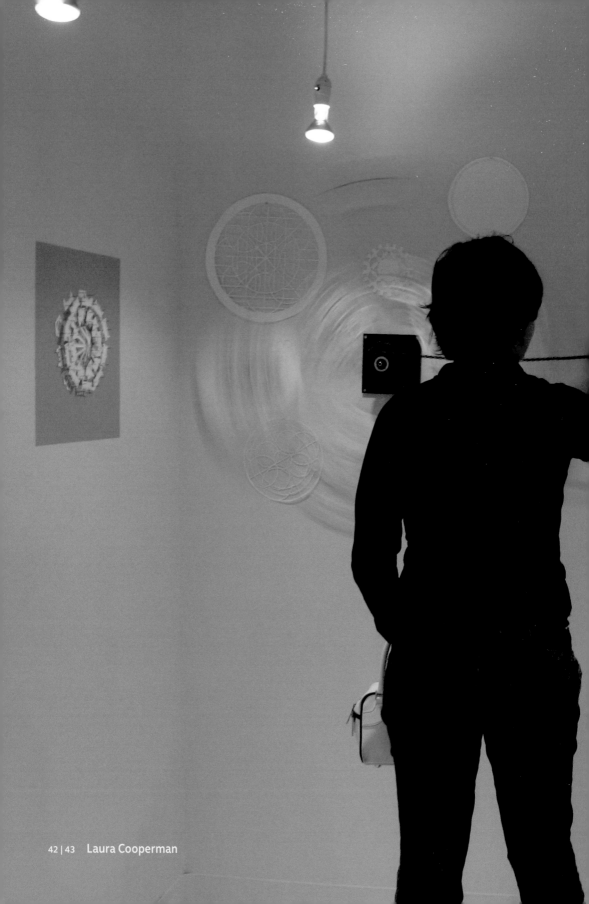

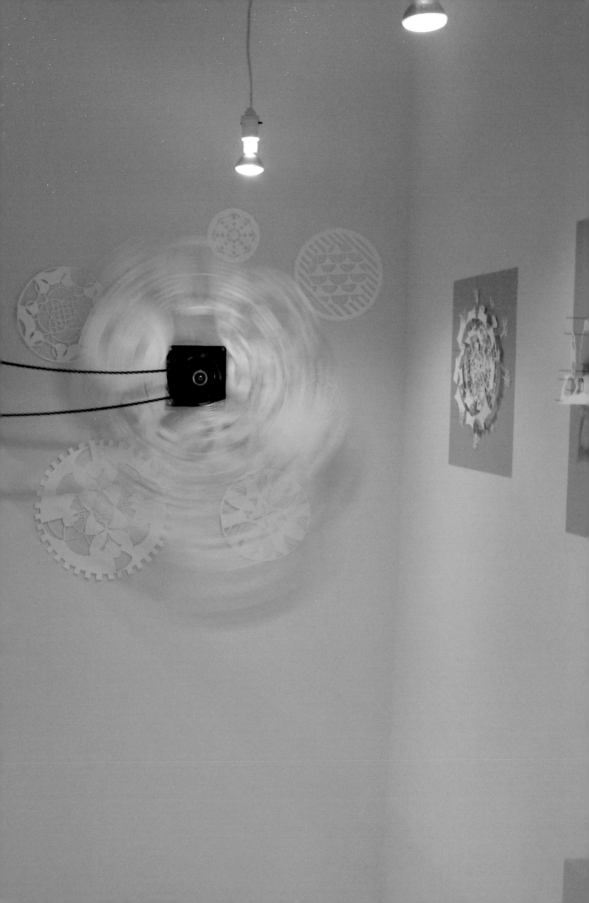

Laura Cooperman

Laura Cooperman's paper cuts defy the fragile nature of the medium with their moving parts and rotating gears. Each work is meticulously layered and structured, owing a debt to architecture and engineering. Her delicate imagery of houses reveals how buildings are constructed. The complex layers and their shadows play with light and depth, which, along with the movement, gives a sense of fluidity and transience. Cooperman is interested in the changing concept of home, which is no longer fixed in time and space but constructed from collective memory, history and myth. In this age of increased mobility, our notion of home and where we are from becomes more fluid.

While in Staten Island, Cooperman saw clusters of tract homes[1] spring up next to the Fresh Kills Landfill.[2] She says "this inspired a group of paper cuttings depicting my imaginings of the subterranean world beneath these homes. The repetitiousness of the houses, the landscaping and even the cars conjured up kaleidoscopic images I attempted to replicate in my cuttings."[3]

1 Numerous houses of the same design built on a tract of land.
2 This was New York's main landfill site in the second half of the 20th century.
3 Laura Cooperman in an email to Natasha Howes 09/07/2012.

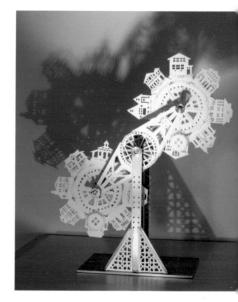

Drill (detail) 2006
Hand cut paper
Courtesy the artist

←
Spin 2005
Wallmounted hand cut paper with metal gears
Courtesy the artist

Born in 1984 into a family of architects in Cleveland, Ohio, USA, Cooperman gained a BFA from the Maryland Institute College of Art in Baltimore. She won scholarships and grants to study in Italy and China and participated in a studio programme in New York. She has had solo exhibitions at Red Gate, Beijing, 2007 and at Meyerhoff Gallery, Baltimore, 2005 and has exhibited in many group exhibitions including in New York, Philadelphia and Baltimore.

Earthly Pleasures (detail) 2012
Cut Tyvec
Courtesy the artist

Béatrice Coron was born in 1956 in France, has lived in Taiwan, Mexico and Egypt before settling in New York in 1984. Coron has had many solo exhibitions including in New York, USA, Antibes, France and Kanoya, Japan and has participated in numerous international group exhibitions. Coron's work is represented in major public collections including the Metropolitan Museum of Art, New York and the Walker Art Center, Minneapolis and she has made many public works of art for such places as subways, libraries, airports and sport facilities.

Béatrice Coron

"My work tells stories. I invent situations, cities and worlds to be explored to make sense of our own."[1] Béatrice Coron's two dimensional works depict the built or natural environment in epic format. Her black silhouettes can be read graphically from a distance as imaginary and fantastical places, but on closer inspection they are elaborately detailed with vignettes filled with hundreds of figures going about their daily lives – scenes within a scene. Coron's work contains various narratives – sometimes playful but also disturbing, challenging and sometimes macabre. She is inspired by everything she reads and sees including memories, books, people's stories, history and current affairs.

The artist recently described how the images are already inside the paper and she only has to remove what is not in the story.[2] She moved from paper to Tyvek (flash-spun, high-density polyethylene fibres) which is stronger and more durable than paper itself and particularly good for her large scale work.

Chaos City 2010 is an urban planning nightmare, a vision of numerous multiple occupancy homes overlapping, cheek by jowl and at dangerous angles. Through the windows the inhabitants are performing every conceivable activity from dog walking, dancing, cooking to getting a haircut. The overall composition affords a sense of disorder, turmoil and instability. Is this what it feels like to live in a city?

1 Béatrice Coron, www.beatricecoron.com/statement.html [accessed July 2012].
2 Béatrice Coron gave a public talk for TED (an American non-profit organisation to spread ideas) in 2011 (which can be viewed at www.youtube.com/watch?v=cAGFKYNrQgY&feature=related).

→
Chaos City (detail) 2010
Cut Tyvek
Courtesy the artist

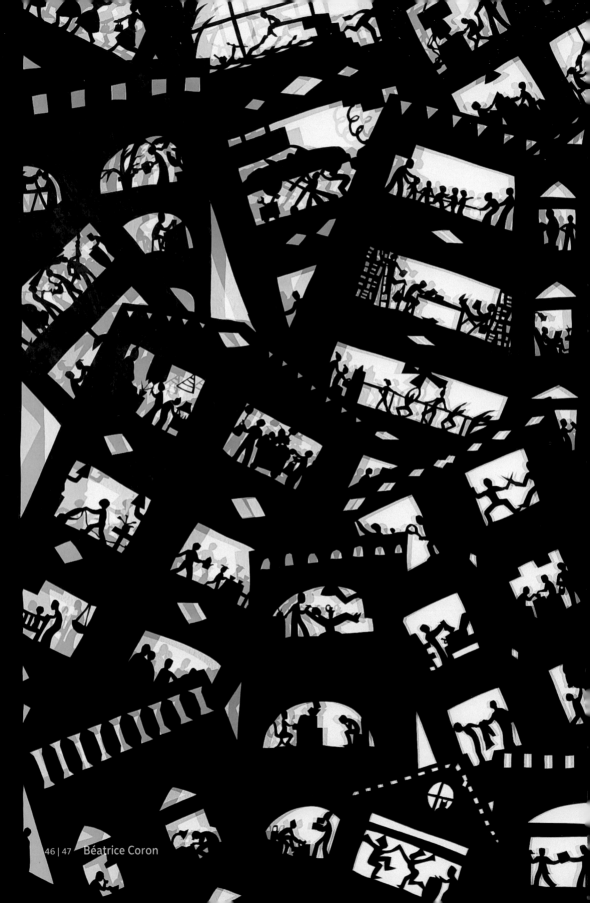

Béatrice Coron

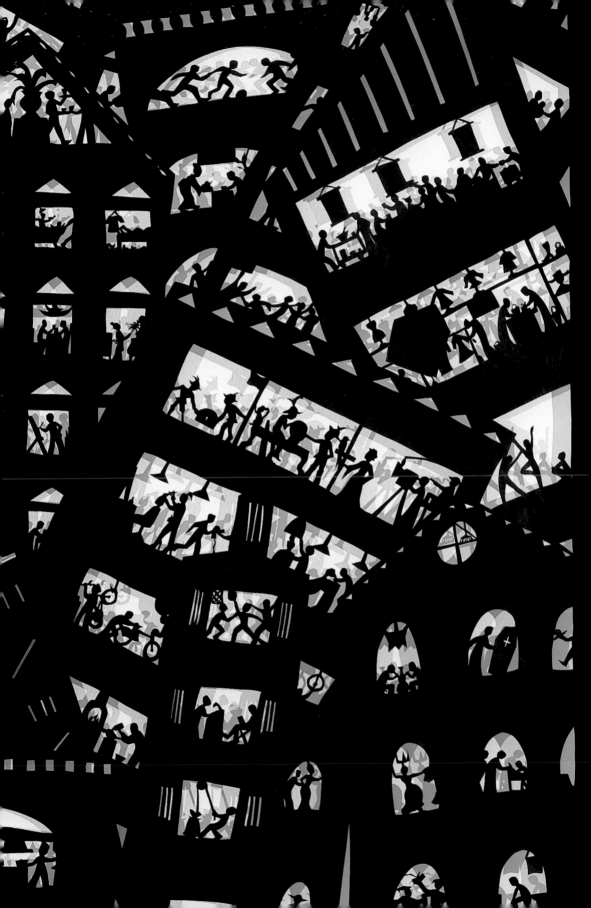

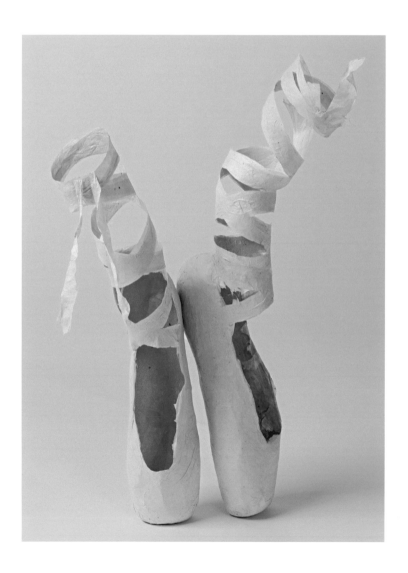

Susan Cutts

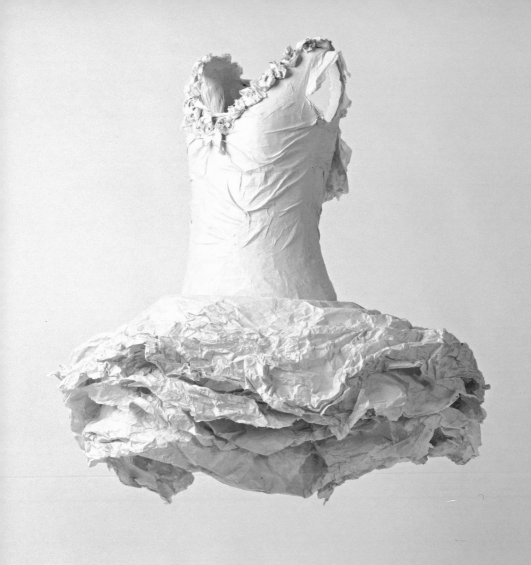
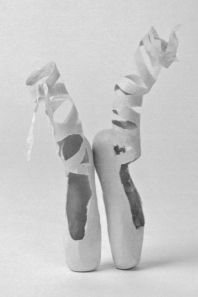

Susan Cutts

Susan Cutts is a sculptor who creates her own paper from raw fibres using traditional equipment and techniques. The process of making the paper is a key component of her work. She carefully selects and prepares the fibres that are used in her handmade paper in order to achieve the desired aesthetic, as well as formal concerns such as strength and flexibility to create her sculptural dresses and shoes. She says of her process "the selection and preparation of the fibres is essential, as they allow, through their complex structure, the creation of sculptural pieces that hold their form without the use of glue, stitching or armatures."[1]

The paper for the work *Who Knows Where the Time Goes* was made from Gampi, a traditional Japanese fibre, which, in virtue of its age and origins "has a reputation for nobility, dignity and richness. With a seductive sheen, Gampi is very often used in fine, tissue-like sheets, and does not bleed when written on."[2] It is the strength and lustrous surface of this material that Cutts appreciates.

Our relationship with clothing is something that Cutts regularly explores in her work. Her dresses will never be worn, yet they seem to be imbued with a sense of presence. For her work in *The First Cut* she says "paper is said to have a memory, the creases, wrinkles and folds hold words unspoken or forgotten. For *Who Knows Where the Time Goes* the absence of the dancer gives the paper power to evoke physical and emotional memories."[3]

Who knows where the time goes (detail) 2012
Gampi paper
Courtesy the artist

1 Susan Cutts in an email to Fiona Corridan 16/07/2012.
2 Paul Sloman in *Paper: Tear, Fold, Rip, Crease, Cut,* Black Dog Publishing, 2009, p. 6.
3 Susan Cutts in an email to Fiona Corridan 16/07/2012.

←

Who knows where the time goes (detail) 2012
Gampi paper
Courtesy the artist

Who knows where the time goes 2012
Gampi paper
Courtesy the artist

Susan Cutts studied Constructed Textiles at the London College of Furniture and Theatrical Corsetry at the London College of Fashion. She is an Associate of the Royal Society of British Sculptors and a member of the International Association of Hand Papermakers and Artists. Cutts has exhibited her work in group and solo shows internationally including Sotheby's Gallery, New York; Roche Court Sculpture Park, UK; Holland Paper Biennale, The Hague, Holland; Jeonju Paper Festival, South Korea and most recently *Cherish*, a solo exhibition at Tudor House Museum, Southampton. Her work is in numerous public collections, including Robert C Williams Museum, Atlanta, U.S.A. and Aberdeen Museum & Art Gallery, Scotland.

Nicola Dale

The book recurs as a theme and a medium in Dale's work. She is interested in how society orders knowledge and how this changes over time, particularly how digital information is superseding our use of books as portals to knowledge. Traditional volumes of encyclopaedias and dictionaries have given way to the growth of reference sites on the internet as our preferred source of research, which can now be accessed at the tap of a button.

Sequel, a new commission for *The First Cut*, is a felled ten foot oak tree, adorned with thousands of individual leaves that are cut from the pages of unwanted reference books rescued from library sales, charity shops and skips. It is Dale's "miniature Tree of Knowledge."[1] For Dale "*Sequel* considers the ways in which the organisation of knowledge is evolving: from the book's rigid, ordered structure, to the web's organic, sprawling growth… each section holds a different branch of human thought. *Sequel*'s form recalls its components' past, but also looks to the future, asking not only where knowledge comes from, but also where it is going."[2]

In her earlier work *Down*, Dale obsessively handcut 12,000 individual feathers from 1970s Ordnance Survey maps to create an evocative installation that referenced journeys and places lost to the passage of time. Now Dale employs the technology that she references in *Sequel*, using a computer programme and domestic laser cutter to generate the thousands of leaves.

1 Nicola Dale in an email to Fiona Corridan 12/07/2012.
2 Ibid.

Down (detail) 20
Hand cut ordinance survey maps
Courtesy the artist

Nicola Dale was born in 1977. She studied at Manchester Metropolitan University and lives and works in Manchester. She is an Associate Member of the Royal British Society of Sculptors (ARBS) and has exhibited in numerous group exhibitions in Australia, America and Europe. She was commissioned to create *Down* for METAL as part of the Liverpool Biennial, 2010 and her work is included in The British Library and Tate Artist's Book Archive collections.

\rightarrow
Sequel (detail) 2012
Oak tree trunk, cut paper
Courtesy the artist
Photo: Alan Seabright, Manchester City Galleries

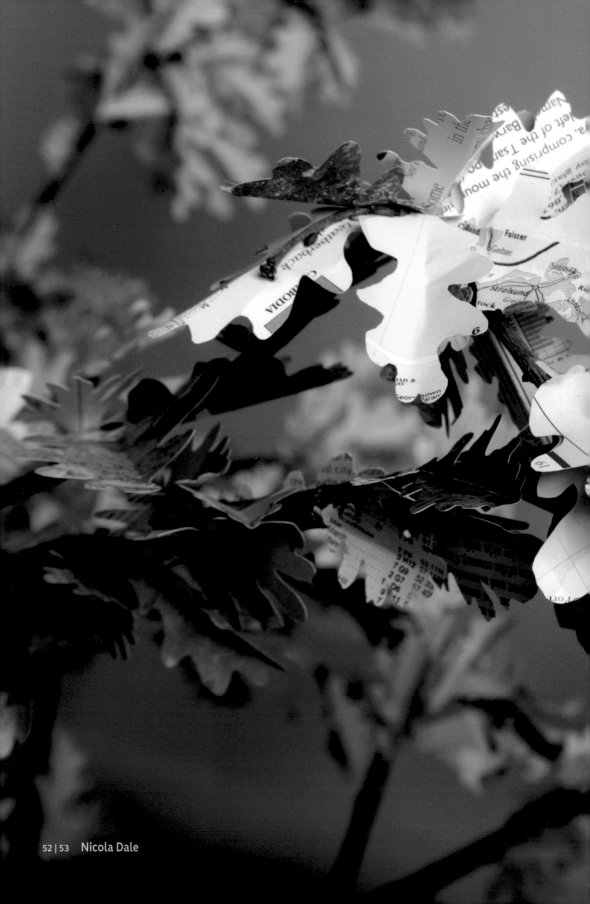

Nicola Dale

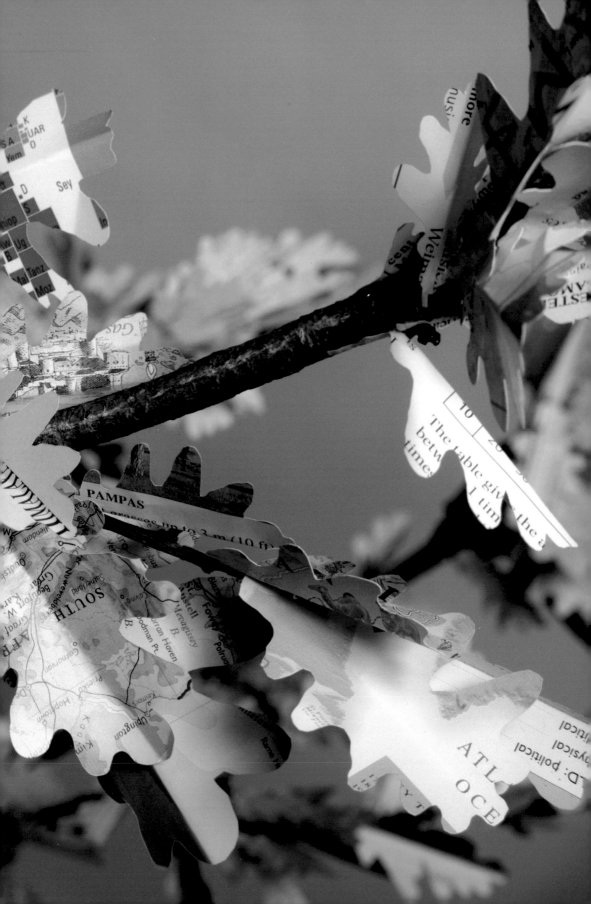

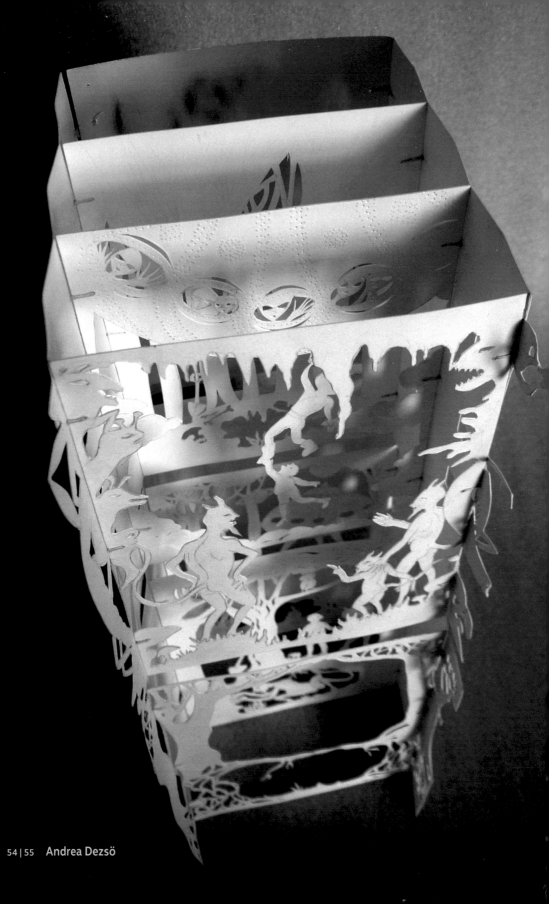

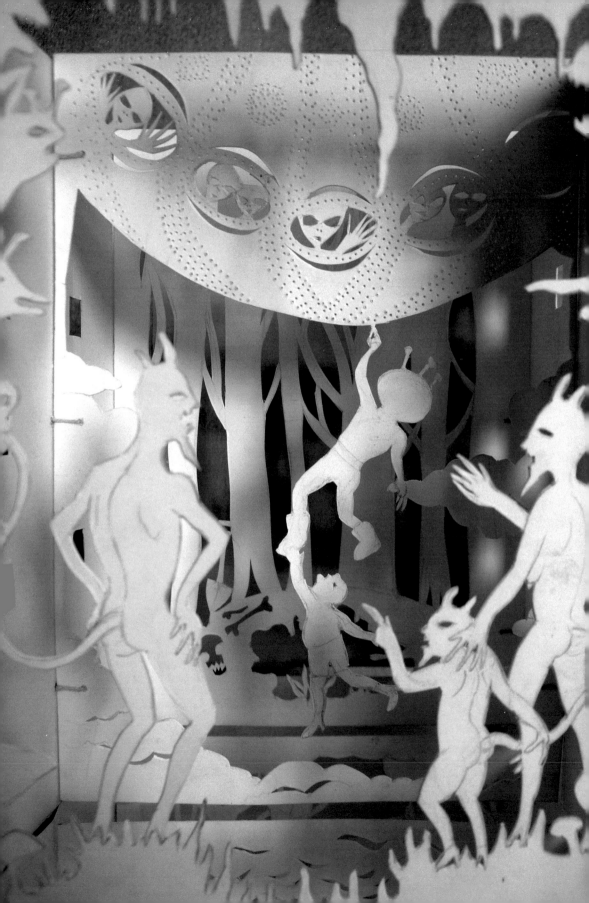

Andrea Dezsö

Andrea Dezsö's varied practice includes drawing, artist's books, cut paper, embroidery, sculpture, installation, animation and public art projects. She grew up in Romania in the 1970s and 1980s under the Communist regime, when it was almost impossible to leave the country. Her only possibilities for travelling were in her own imagination, through dreams, books and storytelling and creating.

Dezsö's tunnel books resemble small, handmade theatre sets with layers of paper to create three-dimensional scenes. The imagery is individually drawn, cut out, and then stacked one in front of another to create a multi-layered world with a sense of depth and detail, which draws the viewer into Dezsö's miniature imaginary worlds. The scenes are non-linear in terms of narrative and the imagery has a surreal quality. Dezsö isn't prescriptive about how these works should be read, but invites the viewer to create their own stories around the characters and environments, based on their own dreams and experiences.

Hybrid creatures populate the tunnel books – anthropomorphic characters that are part human, part animal and part organic form. Dezsö explains "my tunnel books reveal imagined worlds; scenarios arising from the subconscious, based on my personal experience – physical, psychological and spiritual (from) my dreams, memories, anxieties, hopes and obsessions. They refer back to my childhood, which never entirely went away."[1]

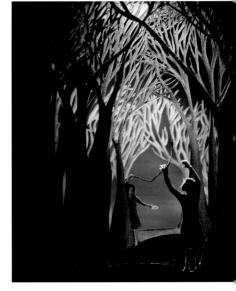

From *Living Inside Tunnel Books* (detail) 2009
Cut-out, hand sewn paper tunnel books with interactive LED lights.
Courtesy the artist
Photo: Péter Hapák

1 Andrea Dezsö, quoted in *Slash: Paper under the knife*, Museum of Art and Design, 2009, p. 92.

←
The Day We Changed Our Lives Forever: Devil's Den 2005
Cut-out, hand sewn paper tunnel books with interactive LED lights.
(LED engineering: Sandy Chen)
Courtesy the artist

The Day We Changed Our Lives Forever: Devil's Den (detail) 2005
Cut-out, hand sewn paper tunnel books with interactive LED lights.
(LED engineering: Sandy Chen)
Courtesy the artist

Andrea Dezsö was born in Transylvania, Romania and now lives and works in New York. She is Assistant Professor of Art at Hampshire College, Amherst, Massachusetts. Solo exhibitions include *Her Kingdom Under The Sea*, Tides Institute & Museum of Art, Maine; *Sometimes in My Dreams I Fly*, Rice Gallery, Houston, Texas and *Things We Think When We Believe We Know*, Frey Norris Gallery, San Francisco. Group exhibitions include, *Slash: Paper Under the Knife*, Museum of Arts & Design, New York. Public art commissions include *Community Garden* 2007 and *Nature Rail* 2012, New York City subway and the forthcoming *Blueberry Garden* for the United States Embassy in Bucharest, Romania to be installed in autumn 2012.

Tom Gallant

Tom Gallant's background in printmaking and training in traditional far-eastern techniques combine with an interest in Victorian society, its arts and crafts. His paper cuts are fragile, decorative and sensually coloured. Looking closer we see that they are made from pornographic magazines: the flesh is both revealed and disguised and we are immediately close up and intimate with pornography. Gallant says "since an early age I have been aware of sexuality, attraction, abuse and power.... (Pornography) speaks on many levels that, on closer inspection, disappear into the tangle of flesh, taboos, icons, repetition and banality."[1] Gallant's appropriated imagery connects to an abusive or absent male reflected in our visual culture.

The Garden of Earthly Delights 2009, which resembles a vertical slice of a Victorian parlour, pays homage to Hieronymus Bosch and the symbols of earth, heaven and hell and references repression in Victorian society. Works from the 2011 series *Old Game Birds* are inspired by Flemish paintings and the language of the *vanitas* in which the transience of earthly life and inevitability of death are combined with beautifully rendered artwork.

The series of text cuts from *101 views* is an exploration of the function of the article in 1970s 'stag' magazines, which was used to bypass censorship laws. By choosing text pages with colour photos behind, the removal of text through the cut reveals the image through reflecting light.

1 Tom Gallant, quoted in *Slash: Paper under the knife*, Museum of Art and Design, 2009, p.120.

Garden of Earthly Delights (detail) 2009
Cut paper, magazine, ink, wood and moulding
Courtesy the artist

Tom Gallant was born 1975 and lives and works in London. After studying at Camberwell College of Art & Design, he held a fellowship at the Royal Academy Schools, followed by a residency at Stichting B.a.d, Rotterdam. He has had many solo shows often based on his *Collector* series in London, Italy and New York. Gallant has been included in numerous group exhibitions including *The Yellow Wallpaper*, Danson House, London, 2012 and *London Twelve*, Prague City Gallery, Prague, 2012 and his work is included in major international collections.

→
Old Game Birds: Still life with Game (After Willem van Aelst) 2011
Cut paper, magazine, paint and glass
Courtesy the artist

Old Game Birds: Still life with Fowl (After Cuyck van Myerop, Frans) 2011
Cut paper, magazine, paint and glass
Courtesy the artist

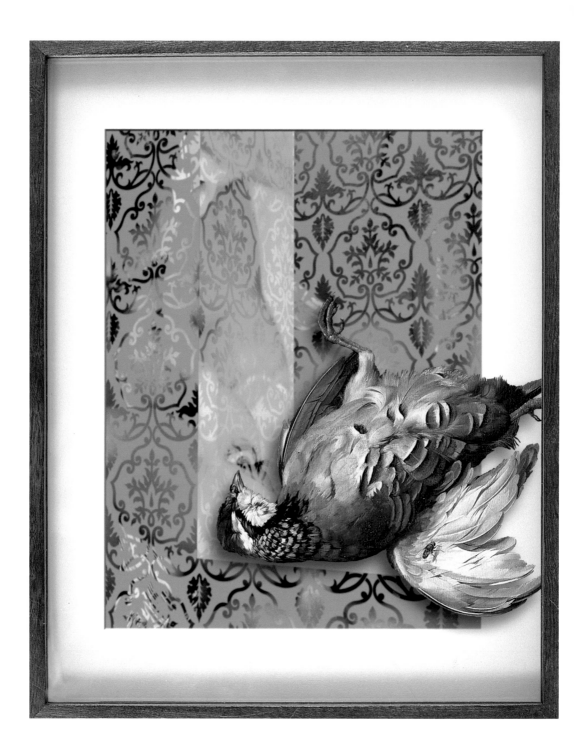

Tom Gallant

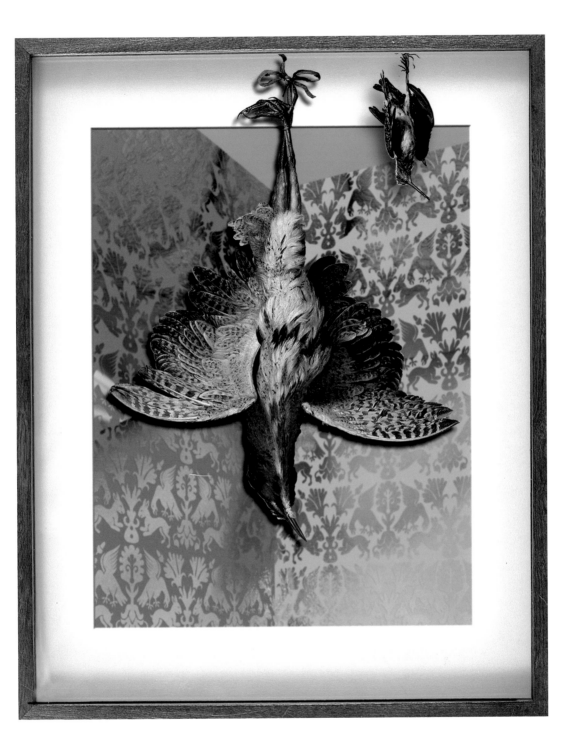

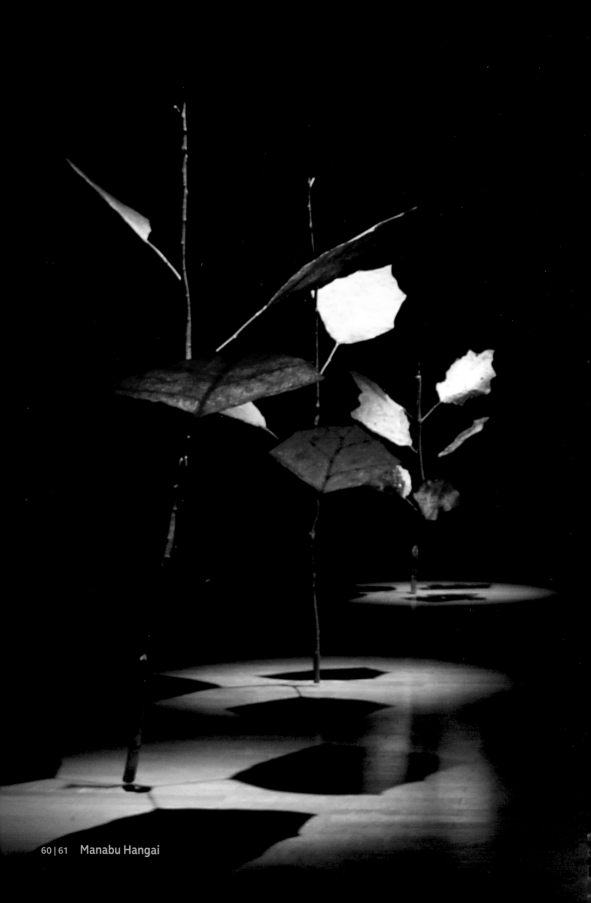

Manabu Hangai

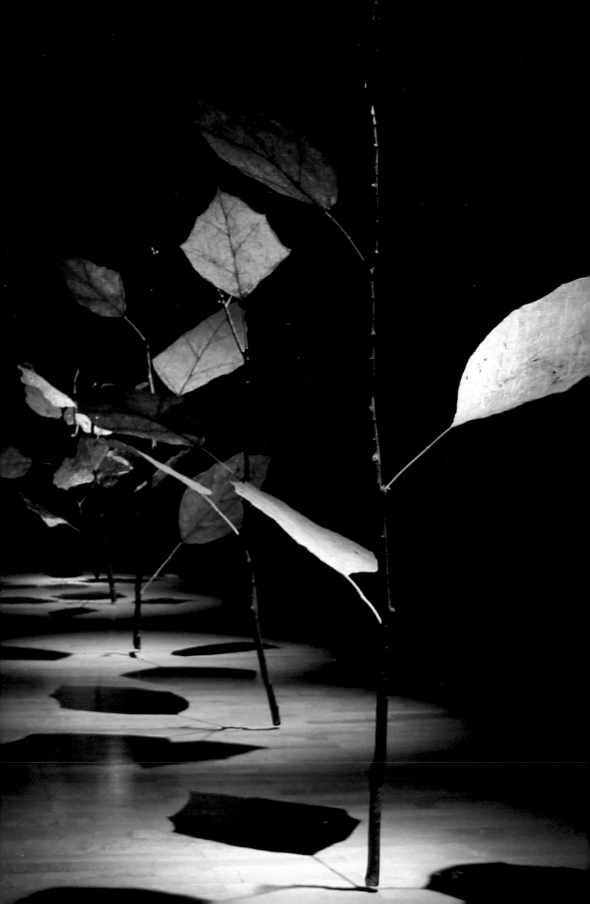

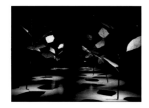

Manabu Hangai

Manabu Hangai uses recycled materials to create his work. He lives near a nature reserve on the island of Hokkaido, Japan and it is this direct connection with the landscape and, more broadly, human interaction with nature that inspires his work. He uses his regular walks on the island as inspiration and as a source for materials, which he collects and re-uses for his artworks. His primary material is the seaweed that proliferates on oyster beds and prevents shellfish growth. This species of seaweed, *hosojuzumo*, is collected for him by local fishermen. Hangai has developed a process to transform this discarded material into paper, which he uses to create stunning installations and suspended forms. For *The First Cut* Hangai has created *Wonder Forest*, using local branches with Japanese leaves to create an immersive and experiential environment which visitors can walk through.

"I love the forest. I spend time meditating among the great trees and beautiful flowers and I'm so aware of how many forests have been and continue to be lost. I am one of many people who would like to revive these lost forests, so I make my own mysterious forests by recycling unwanted or unnecessary things. For a while now, I've been questioning our 'throw away' culture and I try to work with unwanted materials, transforming them and their negative connotations of 'garbage' into things of beauty."[1]

1 Manabu Hangai in an email to Fiona Corridan 16/07/2012.

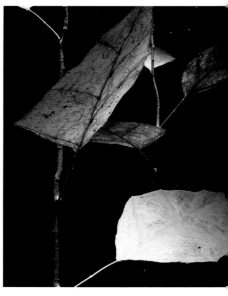

Wonder Forest (detail) 2012
Seaweed raw hemp paper pigment (Hosojuzumo), recycled materials (petal, leaf, toys, brochures, flyers, ribbon, seashells, etc.)
Courtesy the artist

←
Wonder Forest 2012
Seaweed raw hemp paper pigment (Hosojuzumo), recycled materials (petal, leaf, toys, brochures, flyers, ribbon, seashells, etc.)
Courtesy the artist

Manabu Hangai was born in 1963 and lives and works in Hokkaido, Japan. He has exhibited in numerous solo and group exhibitions internationally, including at the Schema Art Museum, Korea; Deco Galeria, Sao Paolo, Brazil; *Holland Paper Biennial*, Museum Rijswijk and CODA Museum, Apeldoorn, Netherlands; Imadate Art Museum, Japan and Centro Cultural Hispano, Salamanca, Spain. His work is in public collections including Hokkaido Obihiro Museum of Art, Hokkaido, Japan and Lias Arc Museum, Kesennuma, Japan.

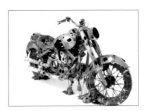

Chris Jones

Chris Jones appropriates existing imagery of photographs, magazines and books. He favours the imagery and paper quality of vintage encyclopedias and high end fashion magazines. Uninterested in their frozen perfection, he renders the images so they are in a state of decomposition and regrowth. Jones's figurative sculptures are exquisitely detailed but equally disturbing as they decay and succumb to an organic process. Frequently an initial random layer is left peeping through the rogue imagery like an incongruous growth or infection. This process of entropy, which has been described as "material transubstantiation,"[1] Jones defines as "the initial mimetic project becoming distracted and beginning to leak extraneous pictorial information."[2]

Recurrently drawn to things which facilitate flux, Jones has made a series of vehicle works including *Upon the End of Your Feral Days* 2011. The motorbike is insect-like, an engine surrounded by an exoskeleton, and this formal ambiguity is enhanced by Jones playfulness with time zones and different terrains. In *The Earl* 2012, Jones has responded to the copies of the Elgin marbles which line the entrance hall at Manchester Art Gallery.[3] Issues of simulacra, authenticity, displacement and ownership chime with ongoing themes in his work. Elgin contracted a skin disease, mirroring the damage sustained to the original classical reliefs over time. Statues generally capture the human form at its optimum, immune to the body's impermanence and inherent frailty. Jones takes the opposite view and his figure is lovingly made into a state of fragile disrepair and decay.

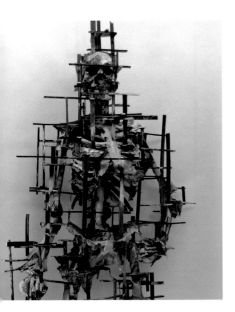

The Earl (detail) 2012
Magazine and book images, paper board, wire and polymer varnish
Courtesy the artist

1 Benjamin Genocchio in *Installations Worthy of the Name*, New York Times 22 June 2008, www.nytimes.com/2008/06/22/nyregion/nyregionspecial2/22artswe.html?_r=2 [accessed 4 August 2012].
2 Chris Jones in an email to Natasha Howes 02/08/12.
3 These were for students to learn drawing when part of the building housed Manchester's school of art and design from 1838 to the 1880s.

Chris Jones was born in 1975 in Preston and lives and works in London. He studied at the University of Central Lancashire, Preston and Central St Martins College of Art and Design, London. He has had solo exhibitions in New York City, Peekskill NY and Amsterdam and has been included in numerous group shows including in Berlin, New York, Ghent and Beijing.

→
Upon the End of Your Feral Days 2011
Magazine and book images, paper board, wire and polymer varnish
Courtesy the artist

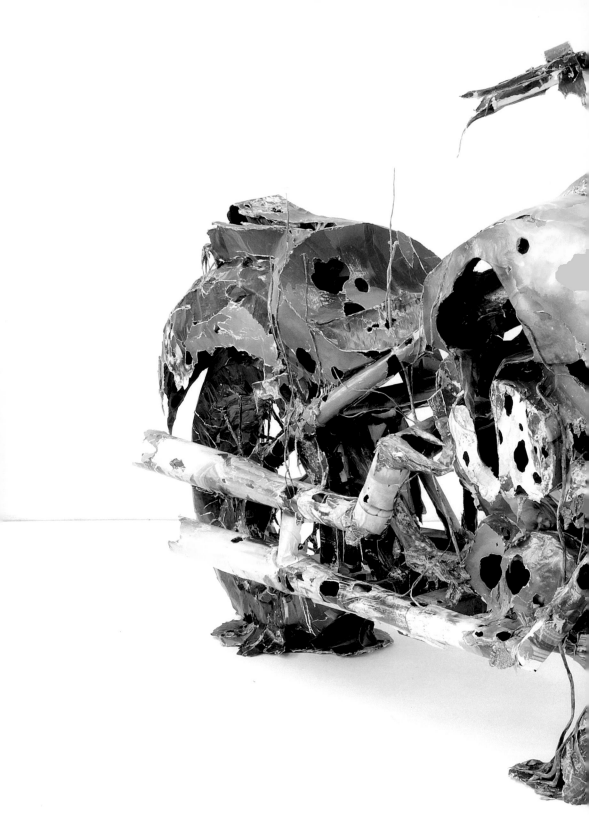

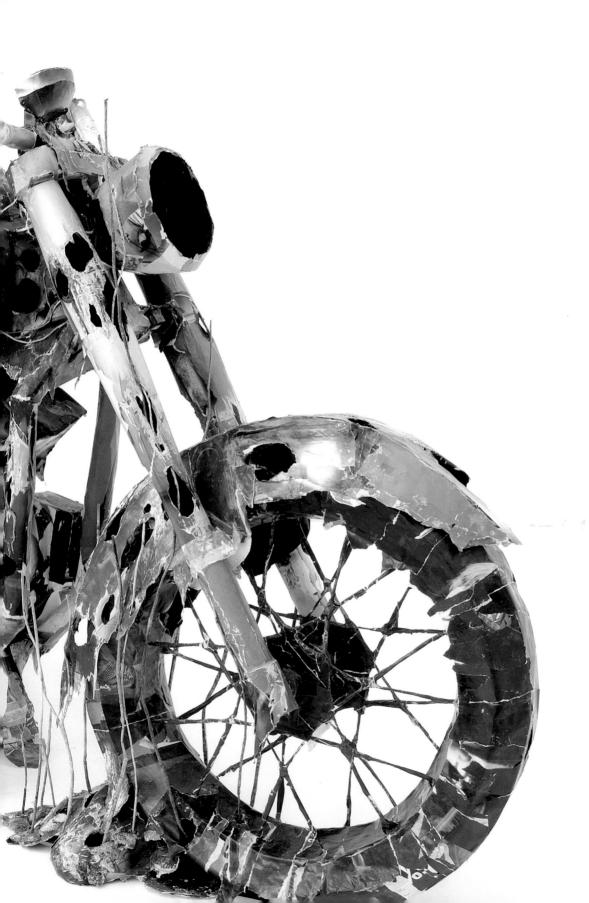

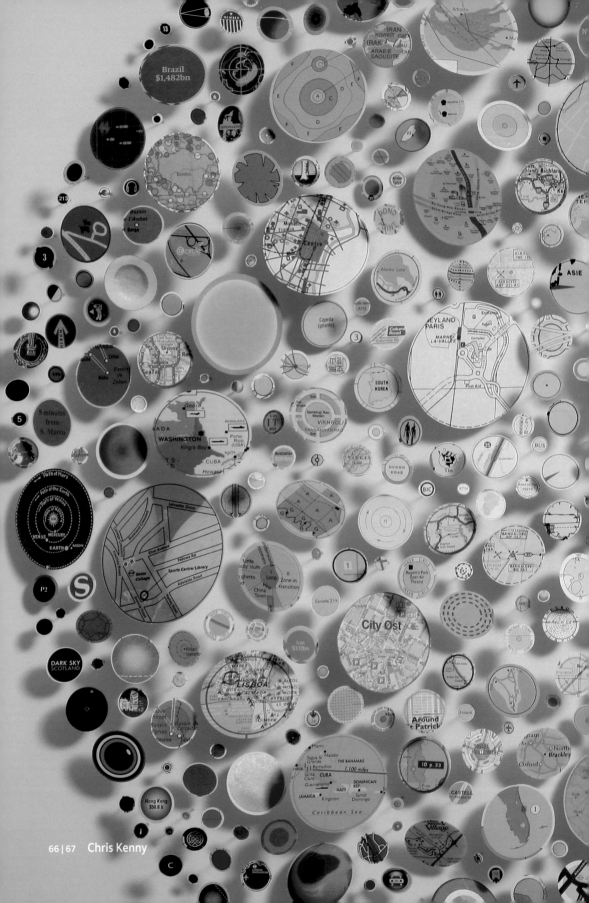

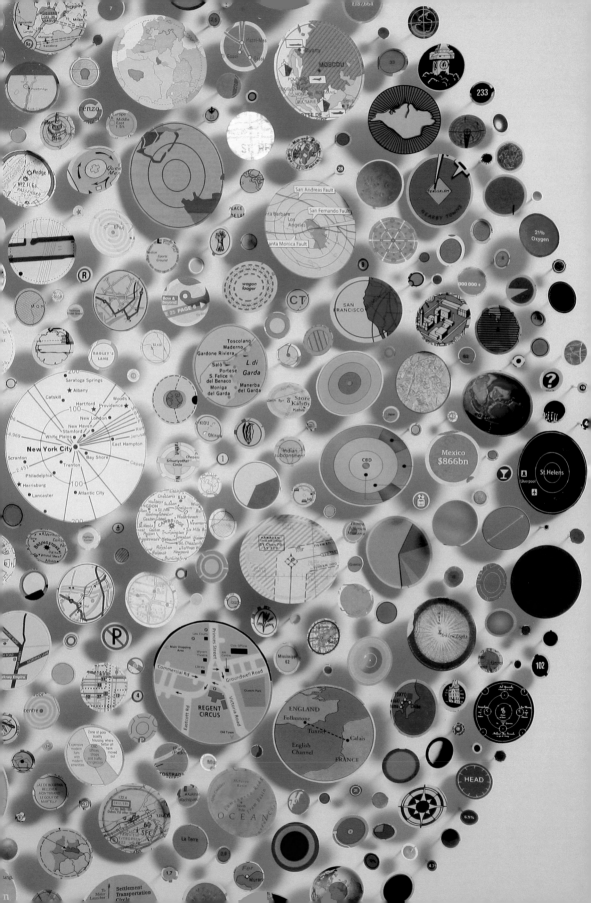

Chris Kenny

Chris Kenny creates collages from found ephemera, usually presented on pins like natural history specimens. For his text works he harvests phrases and sentences from hundreds of second hand books, categorising and ordering them. By subverting and re-presenting these text fragments he constructs new logical but surreal narratives, inspired by the Dadaists love of randomness and chance. In the installation *Cultural Instructions* 2012, Kenny magnifies found instructions, displaying them in a vertical line. Released from their original context Kenny explains that "the instructions bully or cajole the viewer into envisaging an alternative way forward, virtual, limitless and absurd. We are constantly being told what to do and how to be – by government, media and art. I am adding to the load so that it may be necessary to stop momentarily and adjust your baggage."[1]

Kenny's map works combine his painterly approach with an interest in classical abstraction, geometry and the politicisation of cartography. *Capella* 2012 is named after the sixth brightest star. This teeming galaxy of circular decorative and colourful graphic representations is displayed from white to black from the centre outward. The overall circular composition references the view through a telescope or from a microscope into a petri dish. Kenny has described the way he has presented the geological, political, statistical and pedestrian information as "a fetishistic accumulation of data. The teeming spots imply human presence and ownership and draw attention to burgeoning population and territory marking."[2]

Capella 2012
Mixed media construction with map pieces
Courtesy the artist and England & Co, London

1 Chris Kenny in an email to Natasha Howes 14/08/2012.
2 Ibid.

←
Capella (detail) 2012
Mixed media construction with map pieces
Courtesy the artist and England & Co, London

Chris Kenny was born in 1959 in London where he lives and works. He studied History of Art at the Courtauld Institute. He has exhibited widely, made installations for the Courtauld Institute and Dr. Johnson's House Museum, London and was recently included in *Mappa Mundi*, Berardo Museum Foundation, Lisbon, Portugal and in *Slash: Paper Under the Knife*, Museum of Art & Design, New York, USA. Acquisitions of his work have been made by the British Museum, Victoria & Albert Museum, Museum of London and Tate, London (artists books collection).

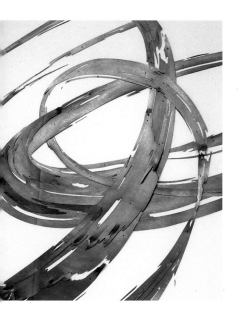

Model for *Paperwork #1213G* (detail) 2012
Graphite on watercolour paper
Courtesy the artist

Andreas Kocks

Andreas Kocks creates large scale three dimensional installations, which respond to the architecture of a gallery, drawing on his background in architecture and sculpture in metal. His wall pieces, composed of inky black graphite-laden paper, seem to explode with full force and appear as giant splashes on gallery walls. It is this contradiction between the lightness and fragility of the paper and the intensity of this 'explosion' that lends Kocks' works their power. They create a dynamic sense of movement which sweeps across and around a space, as though a hurricane suspended in time. His forms have recently begun to resemble huge brushstrokes, bringing together three artistic disciplines – drawing, painting and sculpture – to create one monumental work.

Kocks' creative process begins with a drawing based on the dimensions of the space. After producing a watercolour, he creates a model at scale 1:10. He then draws the fluid, organic forms to scale on graphite coated paper, which he cuts out. Finally he installs the layers piece by piece onto a wall. Kocks explains "I want my work to get into direct contact with its locale. This is why my pieces are unframed and mounted directly on the wall. The contrast between my organic shapes and the orthogonal space is significant. In this way, especially if the work is large, the viewer is invited to move, to change his position and thus modify his viewpoint. He then experiences the dynamic processes inside the work and is forced to look at real space in a different way."[1]

1 Andreas Kocks in an email to Fiona Corridan 28/07/2012.

Andreas Kocks was born in 1960 in Oberhausen, Germany and lives and works in Munich and New York. He studied Fine Art and Architecture and then Sculpture at the Kunstakademie Düsseldorf. Kocks' work has been shown since the mid-1980s in Europe and the U.S.A. He has been developing a reutation for site-specific works for private and public collections. He was awarded the Pollock-Krasner Grant in 2006/07.

→
Paperwork #939(3)G 2009
Graphite on watercolour paper
Courtesy the artist and Winston Wächter Fine Art, New York
Photo: Hermann Feldhaus

Paperwork #1145G 2011
Graphite on watercolour paper
Courtesy the artist and Winston Wächter Fine Art, New York
Photo: Adam Reich

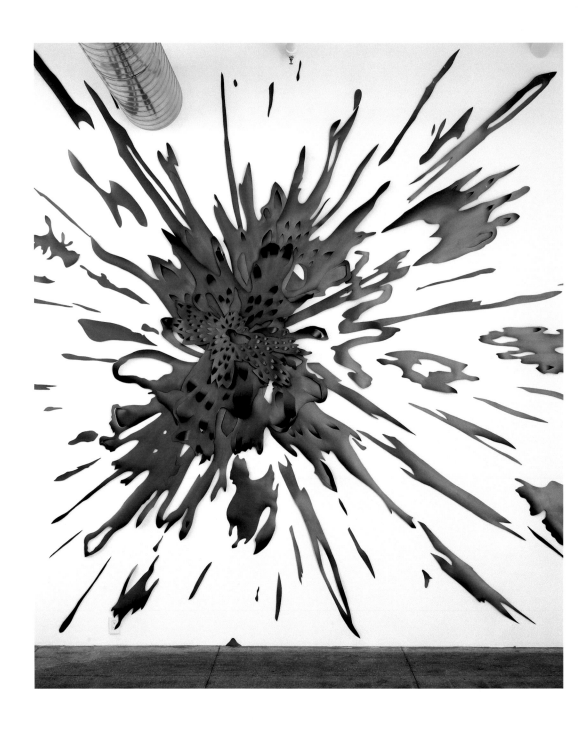

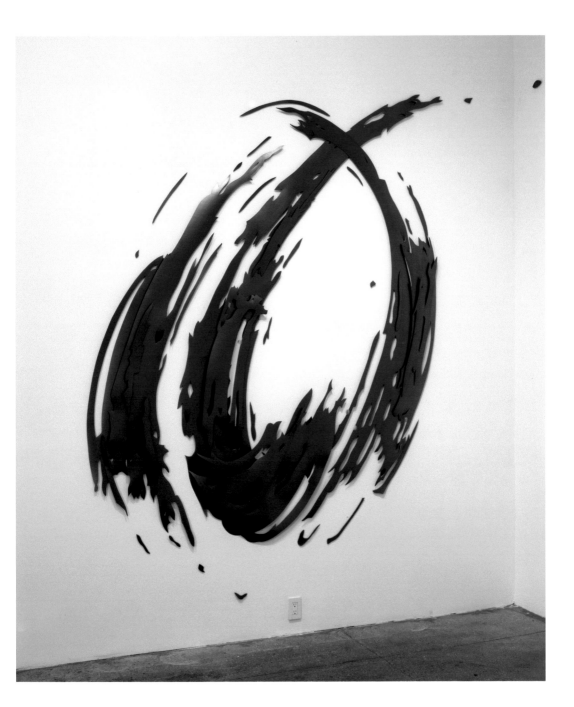

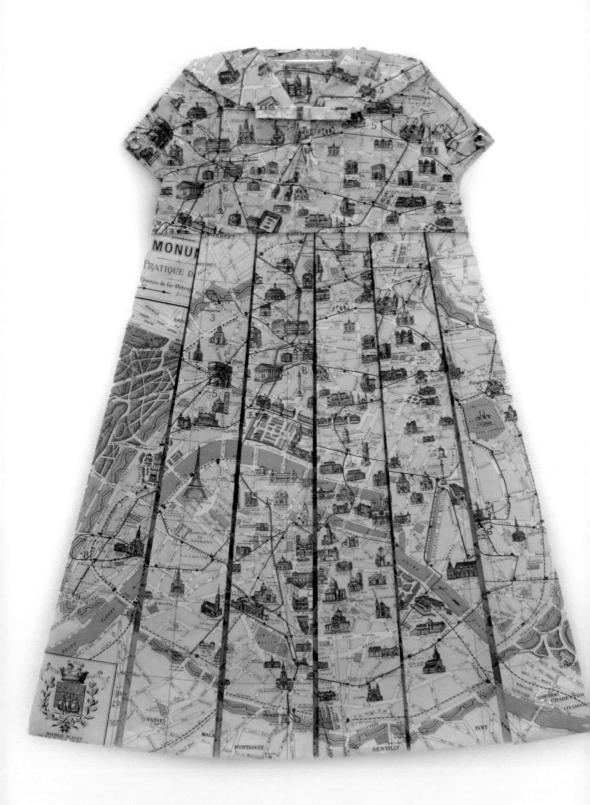

Elisabeth Lecourt

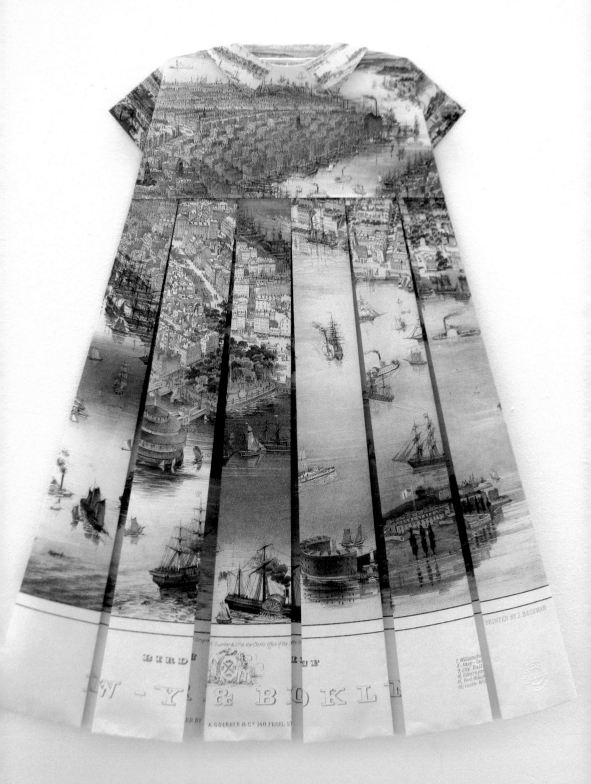

Elisabeth Lecourt

Using historic maps, Elisabeth Lecourt fashions children's dresses complete with pleats, buttons, collars and frills. Although one cannot wear the dresses from the series *Les Robes Géographiques*, they speak of the absence of the body. For Lecourt the body is a site of personal narrative – of emotions, identity and history. Her first child's dress was inspired by the story of Anne Frank who was in hiding from the Nazis for two years. Lecourt's own past influenced this body of work as she had to leave behind her childhood in France and move to the UK.

Lecourt carefully sources lavishly illustrated and delicately coloured historic maps, often from the 19th century. They range from world views, maps of countries and street layouts, like *Le Tablier d'Encre* 2012 made from a panoramic map of New York dating from 1851. Enjoying the physicality of making the dresses and the precise cuts and folds, Lecourt likens herself to a surgeon.[1]

The style of these dresses is not practical for today's girls – no good for riding bikes or climbing trees – but are an archetype of childhood innocence and purity. They require the wearer to behave in a certain way and have an unrealistic expectation of a clean and well-mannered child. Lecourt has spoken of how the dress which we are put in when we are small, affects the person we become.[2]

1 Elisabeth Lecourt lecture for Design Week, 2008 available at www.elisabethlecourt. com/about/watch-conference/ [accessed August 2012].
2 Ibid.

Le Petit Pois Magique (detail) 2012
Map of Paris Monuments
Courtesy the artist

←
Le Petit Pois Magique 2012
Map of Paris Monument
Image courtesy the artist

Le Tablier d'Encre 2012
Panoramic map of New York rep.1851
Courtesy the artist

Elisabeth Lecourt was born in 1972 in Oloron Sainte-Marie, France and lives and works in London. Her education includes studying at Central St Martins College of Art and the Royal College of Art, London. She has had solo exhibitions in London, Paris, Amsterdam and Rotterdam and has participated in numerous groups shows in Sweden, USA, Italy, Netherlands, France and Germany. She is regularly commissioned by private collectors and her work features in the Arts Council Collection.

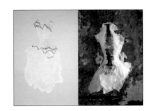

Violise Lunn

Violise Lunn is an avid collector of paper of all kinds. She experiments with papers of different textures, weights, colours and opacity, which she tears, scrunches, paints, lacquers and glues to achieve the texture and structure required for her ethereal floating dresses and shoes. She is often led by the way particular papers respond to her actions and says that "sometimes the paper takes control, a shape appears and it seems to take on a life of its own."[1]

Lunn strives to give form to the realm of dreams or otherworldly thoughts and she likens her sculptural dresses to remnants of skin, which have been "shed like a snake" and her shoes as "creeping insects."[2] Other random objects, such as vintage banknotes and ornaments that the artist collects inspire the direction or theme of particular works and personal memory and ritual are also referenced.

Lunn elucidates "some of my works in *The First Cut* draw inspiration from old prints of organs and skeletons, which have led to a body of work that resembles dancing ghosts: one can almost hear the bones rattle. They also make me think of the Mexican Day of the Dead, when ancestors are honoured and families gather in cemeteries with personal momentos and memorabilia to encourage souls of the departed to visit."[3]

1 Violise Lunn in an email to Fiona Corridan 13/07/2012.
2 Ibid.
3 Ibid.

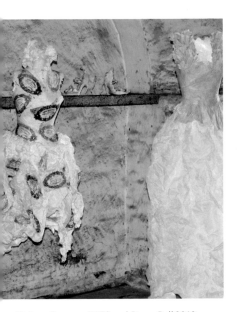

Vintage Currency 2000 and *Paper Ball* 2010
Paper and glue
Courtesy the artist

Following her graduation in Industrial Design and Fashion at Denmark's Design School, Violise Lunn opened her own studio and atelier in the centre of Copenhagen, where she makes both paper sculptures and dresses, as well as working with fabric and porcelain. Recent exhibitions and projects include *Sofia International Paper Art Biennale*, Bulgaria and *Souliers* at Maison du Danemark, Paris.

→
White Dress 2007
Paper and glue
Courtesy the artist

Spine 2003
Paper and glue
Courtesy the artist

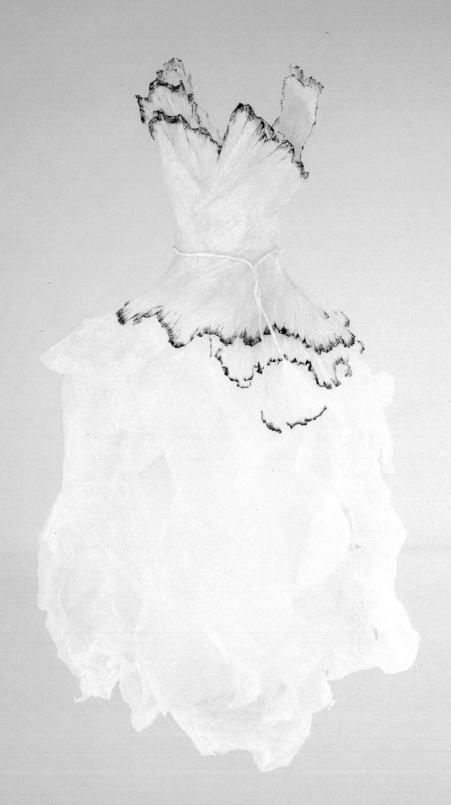

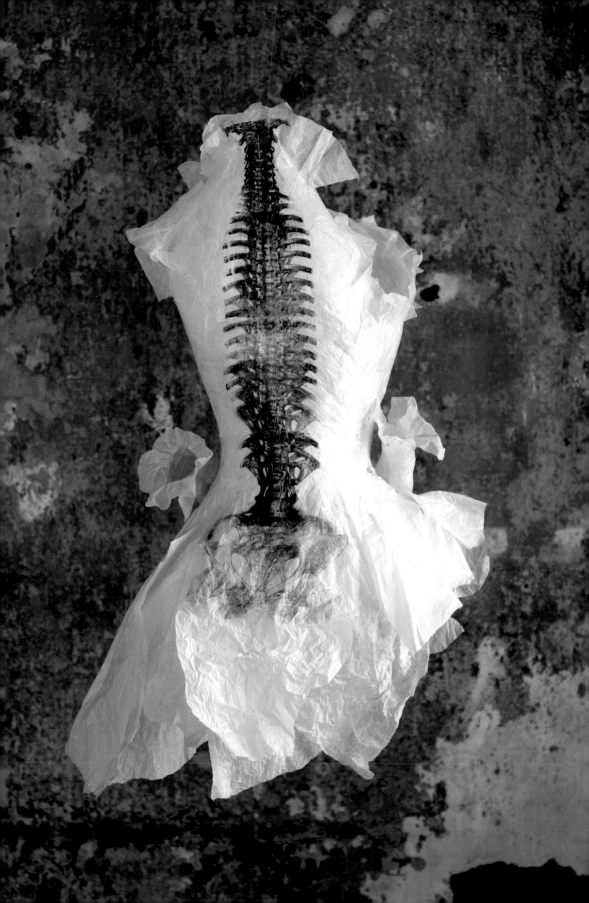

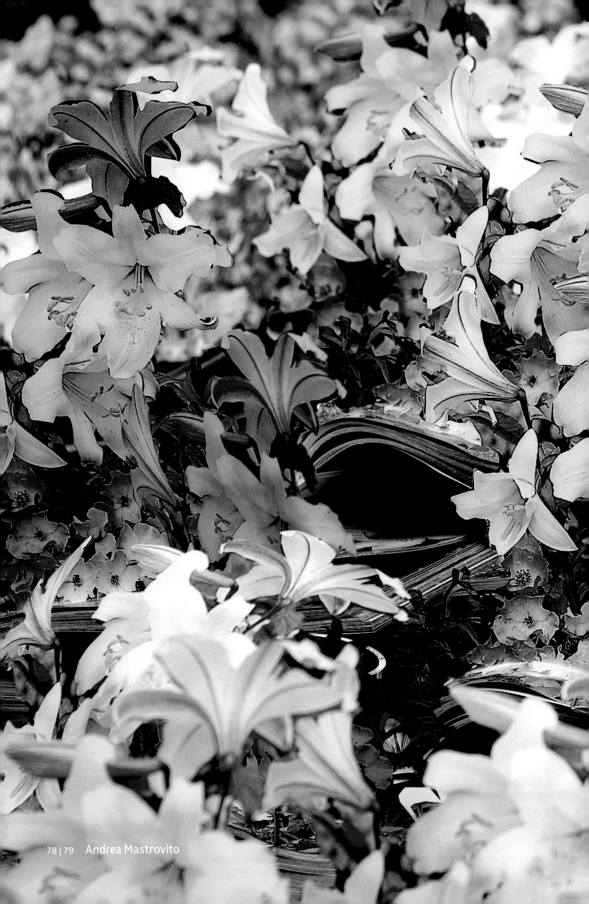

Andrea Mastrovito

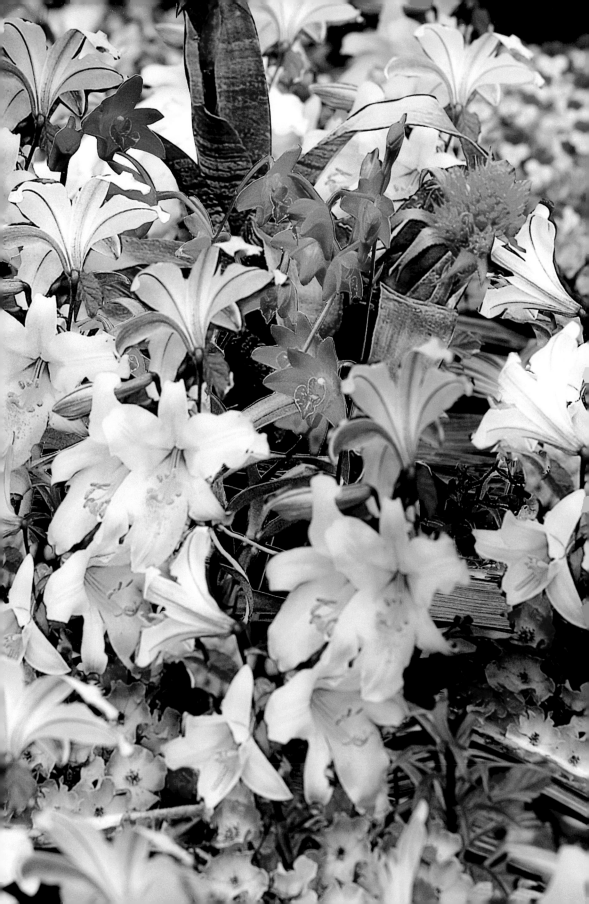

Andrea Mastrovito

Paper sculptures are only one aspect of Andrea Mastrovito's work but even when working in film and video, performance or photography, paper is often a central device. He uses paper because of its simplicity and directness. He explains "I want to show how things are born and are filtered through my work."[1] He leaves no personal trace and says "I like to hide my intervention. … I make clean but totally impersonal cuts."[2]

Mastrovito has produced a series of sculptures inspired by the natural world using many varieties of flowers or species of animals. *EXODUS:8:13* refers to the Bible passage in which God inflicted a plague of frogs on Pharaoh. This impressive floor installation is a geometrical garden full of foliage and flowers, cut from seed and plant catalogues, which are pushed upright. The garden is invaded by animals and jumping frogs, which references a Victorian dollshouse filled with stuffed frogs in Manchester Art Gallery's collection.[3] The work plays with the notion of reality and artifice. The imagery comprises photographic reproductions of actual blossoms which make you want to bend down and smell them, despite seeing the catalogues from which they are taken, overlaid on the floor. Mastrovito describes the cyclical nature of this work. "In the beginning you've got a flower. From the flower comes a tree. From the tree we obtain wood, from wood paper and from paper books. And in the end, with just few cuttings, I've gone back to the original flower."[4]

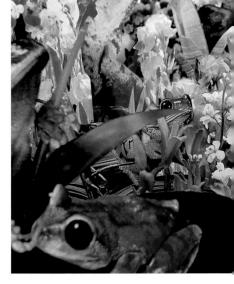

EXODUS:8:13 (detail) 2012
Cut paper
Courtesy the artist

1 Andrea Mastrovito quoted in *Slash: Paper under the knife*, Museum of Art and Design, New York 2009, p. 164.
2 Ibid.
3 *Frog House*, 1840, accession number 1922.213.
4 Andrea Mastrovito in an email to Natasha Howes 15/07/2012.

←
Enciclopedia dei fiori da giardino 2009
Cut paper
Courtesy the artist

Andrea Mastrovito was born in Bergamo, Italy in 1978 and lives and works between Bergamo and New York. He studied at the Accademia Carrara di Belle Arti, Bergamo and received the New York Prize awarded by the Italian Ministry of Foreign Affairs and the Analix Forever Residency award. In 2012 he was one of the winners of the Moroso Prize for Contemporary Art, New York. He has been accorded solo exhibitions in Milan, Florence, Geneva, Brussels, Paris and New York and has taken part in numerous international group shows.

Mia Pearlman

Mia Pearlman makes site-specific cut paper installations in both two and three dimensions inspired by weather systems and the natural world. She describes her work as "ephemeral drawings that blur the line between actual, illusionistic and imagined space."[1] Her process involves making loose India ink line drawings from which she cuts out selected areas, or paints and slices the paper. The intuitive assemblage[2] of many of these two dimensional paper cuts produces dynamic sculptures, animated by a natural or artificial light source. She makes weather tangible, frozen in an ambiguous moment, which seems to burst through the architecture or hover within a room.

ROIL, made for *The First Cut*, is part of a new body of work, based on the idea of water as a metaphor for the passage of time and the relationship between all things. It also engages with ideas of creation and destruction, natural and cosmological cycles, what the universe is made of and how we relate to it. Pearlman was inspired by Chinese and Japanese art in which nature can be depicted as very stylized or naturalistic, often in the same image. She was deeply influenced by a 17th century screen painting, *Waves at Matsushima* by Tawaraya Sotatsu showing the island amid stylized tumultuous golden waves. She says "soon after I discovered it, the Japanese tsunami happened, and the images of water and destruction were eerily similar."[3]

1 Mia Pearlman in an email to Fiona Corridan 30/07/2012.
2 This is done by trial and error, which she describes as a "dance with chance and control."
3 Mia Pearlman in an email to Fiona Corridan 30/07/2012.

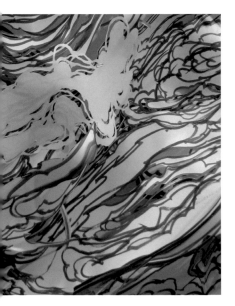

HAVOC (detail) 2011
Paper, India ink, tacks, paperclips
Image courtesy the artist

Mia Pearlman was born in 1974 and lives and works in Brooklyn, New York. She has exhibited internationally, including at the Museum of Arts and Design, New York, Plaatsmaken, Netherlands, Smack Mellon, Brooklyn, the Centre for Recent Drawing, London and the Renwick Gallery at the Smithsonian American Art Museum, Washington D.C. Pearlman has received numerous awards including 2011 Artist Grant from the New York Foundation for the Arts, the 2011 Robert Sterling Clark Visual Arts Space Award and a Pollock-Krasner Foundation Grant 2008.

→
HAVOC (detail) 2011
Paper, India ink, tacks, paperclips
Image courtesy the artist

PENUMBRA (detail) 2010
Paper, India ink, tacks, paperclips
Image courtesy the artist

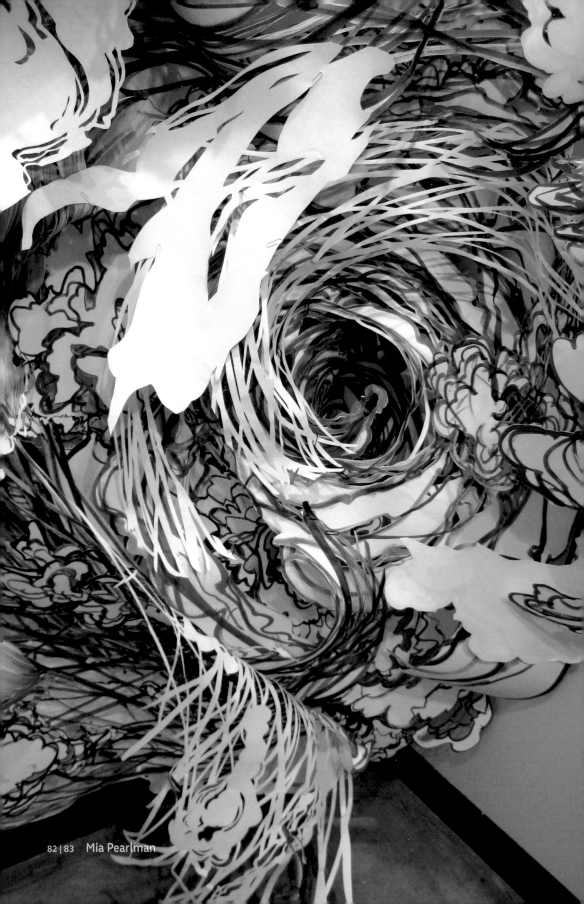

Mia Pearlman

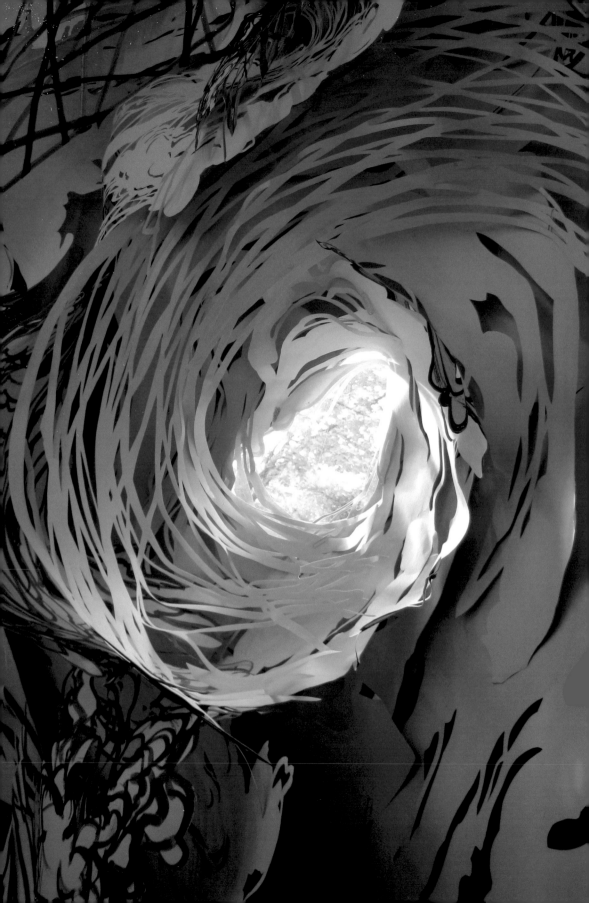

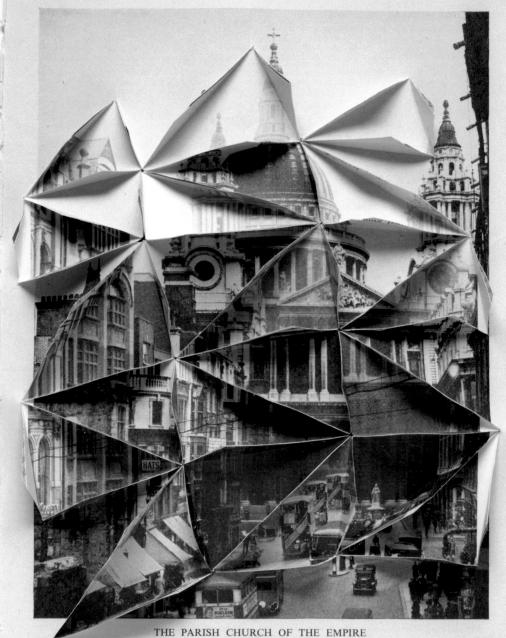

THE PARISH CHURCH OF THE EMPIRE

St. Paul's Cathedral from Ludgate Hill. Built by Sir Christopher Wren between 1675 and 1710, it has an
exterior length of 515 feet and a width across the transepts of 250 feet. The height from the pavement of
the church to the top of the cross is 365 feet. The diameter of the drum beneath the dome is 112 feet.

84 | 85 **Abigail Reynolds**

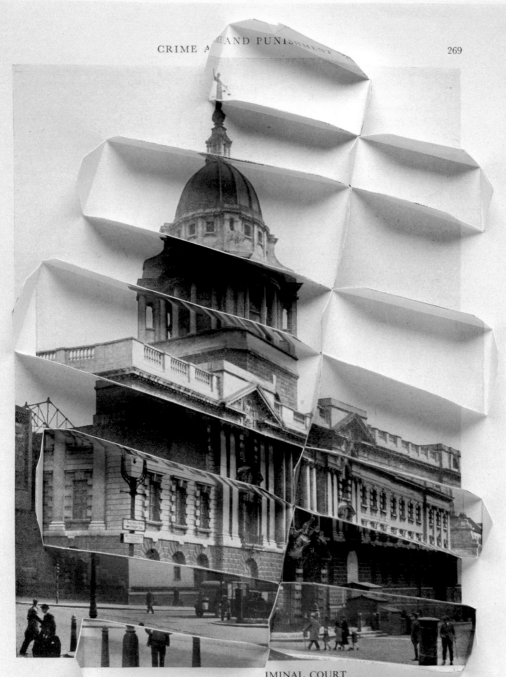

BRITAIN'S FOREMOST CRIMINAL COURT

The Central Criminal Court, known as the Old Bailey "Old Bailey" sessions-house, and is still popularly known by that name. King Edward VII in 1907, it has s on the site of Newgate Prison, was opened by King Edward VII in 1907. It ha which his Majesty's j d tiled central hall, off which are the four court rooms. The north-west corner of the foreground) was destroyed by a bomb in 1940.

1950/1958

Abigail Reynolds

Abigail Reynolds is a collector of second-hand guide books, seeking out vintage photographs of landmarks, monuments and landscapes taken from the same position by separate photographers at different times. Finding two such images, printed at a similar scale, Reynolds merges them together through a series of incisions and folds.[1] She uses a range of geometries for these works which form the series *The Universal Now*, the title referring to a quantum physics debate about whether there can be a universal now across the whole of the solar system. Parts of the two images line up uncannily and whilst the landmarks stay the same over time, the environs and print technology have changed, causing a sense of dissonance and rupture in time. Reynolds says "the act of folding one image into the other pushes them out into three dimensions in a bulging time ruffle"[2] and she asks us to consider our own moment in time and our desire to escape our own present.

The Wonderful Story of London, Editions One and Two, 1936 / 1950 is constructed from a compendium of the history, architecture and lives of the capital's inhabitants, first printed in 1936, and republished in 1950. New photographs were commissioned for the post-war edition but the accompanying text remains unaltered (although minus several chapters). Reynolds selected 24 pages in which the differences between versions were most pronounced and spliced them together. She said "profound changes were effected in the 12 years between the editions – upon the exterior forms of London (due to bombing) but more deeply, affecting beliefs and practices that could not, like buildings, be reconstructed post-war."[3]

The Wonderful Story of London, Editions One and Two, 1936 / 1950 (detail) 2010
Series of 24 framed paper cuts displayed in a grid
Courtesy the artist and Seventeen Gallery

Abigail Reynolds lives and works in St Just, Cornwall. Prior to her MA at Goldsmiths College, London she studied English Literature at Oxford University. Recent solo shows include *The British Countryside in Pictures*, Seventeen Gallery, London and *A Common Treasury*, Ambach & Rice, Los Angeles. Recent group shows include *Topophobia* (touring to Danielle Arnaud, London; Bluecoat, Liverpool; Spacex, Exeter), and the *Helsinki Photography Biennial*. Forthcoming exhibitions include *Dear Aby Warburg, what to do with images?*, Museum fur Gegenwartskunst, Siegen, Germany. Reynolds has work in the Government Art Collection. Since January 2011 she has been a Tate St Ives advisory board member.

1 The entirety of each page is preserved behind the folds.
2 Abigail Reynolds in an email to Natasha Howes 30/7/2012.
3 Ibid.

←
The Wonderful Story of London, Editions One and Two, 1936 / 1950 (details) 2010
Series of 24 framed paper cuts displayed in a grid
Courtesy the artist and Seventeen Gallery

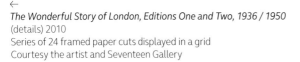

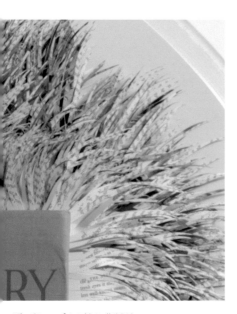

The Story of Art (detail) 2012
Cut book in circular acrylic case
From a series of individual works incorporating
copies of Gombrich's book.
Courtesy the artist and England & Co

Georgia Russell

Georgia Russell transforms found printed paper ephemera, including books, newspapers, maps, banknotes and sheet music. She draws inspiration from the psychologist Erich Fromm, who observed that children often destroy things in order to truly understand them. He said "the cruelty itself is motivated by something deeper, the wish to know the secret of things and life."[1] Russell shreds, cuts and deconstructs paper, attempting to unlock its hidden or potential meanings and suggest new ones.

By dissecting and reconstructing old, discarded books, Russell imbues them with new life. Choosing eminent works like Germaine Greer's *The Female Eunuch* or Ernst Gombrich's *The Story of Art*, placing them in acrylic cases and domed specimen jars, Russell creates "a unique library of literary decimation."[2] The passing of time is evoked by her labour-intensive cutting. She says "there is a simultaneous sense of loss and preservation in each work. Values constantly shift, something once valuable is changed, suspended, and put on show for the viewer to ask What did this object once mean? What memories does it yield? What does it mean now?"[3]

Britain: March 2003 (Britain on Iraq) 2003 was a result of serendipity. On completing a delicate cut-out of a map of Britain from an atlas, she turned the page to discover that overleaf an image of the country was now carved in reverse into a map of Iraq, Iran and Afghanistan. The work was also prophetic as within weeks of completing it, a coalition of Western governments, led by America and Britain, invaded Iraq.

––––––––

1 Erich Fromm *The Art of Loving* (first published HarperCollins 1956) Thorsons, 1995 p. 24.
2 Paul Sloman (ed) *Paper: Tear, Fold, Rip, Crease, Cut*, Black Dog Publishing, 2009, p. 114.
3 Georgia Russell quoted in *Slash: Paper under the knife*, Museum of Art and Design, 2009, p. 204.

\rightarrow
Britain: March 2003 (Britain on Iraq) 2003
Cut map in acrylic case
Courtesy the artist and England & Co

The Story of Art 2012
Cut book in circular acrylic case
From a series of individual works incorporating copies of Gombrich's book.
Courtesy the artist and England & Co

Born in 1974 in Elgin, Scotland, Georgia Russell studied at the Royal College of Art, London and now lives and works in Paris. She has participated in group exhibitions at museums internationally, and has had numerous solo exhibitions over the past twelve years, primarily in London and Paris. Public collections that hold her work include the Victoria and Albert Museum, London and Musée National d'Art Moderne, Centre Georges Pompidou, Paris.

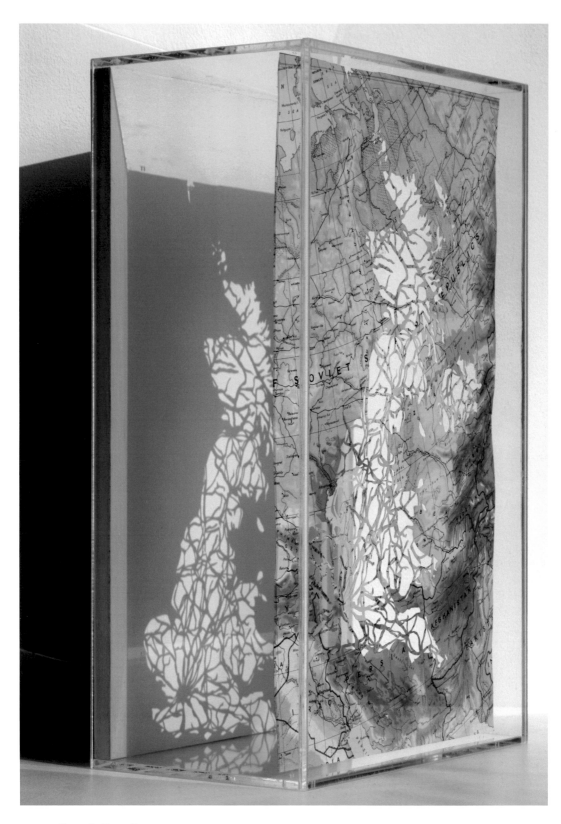

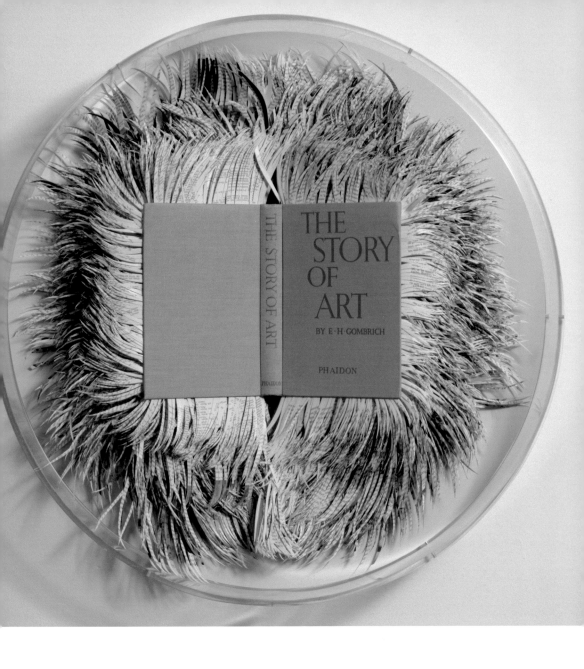

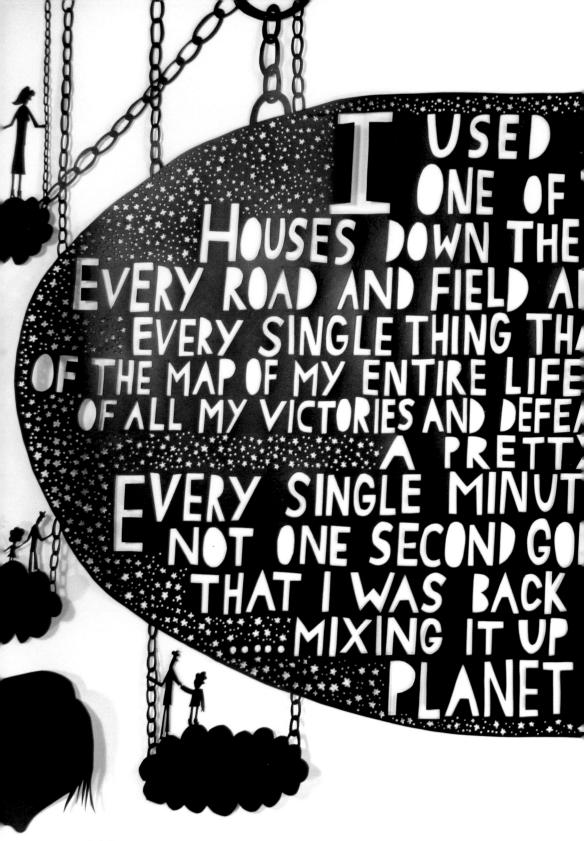

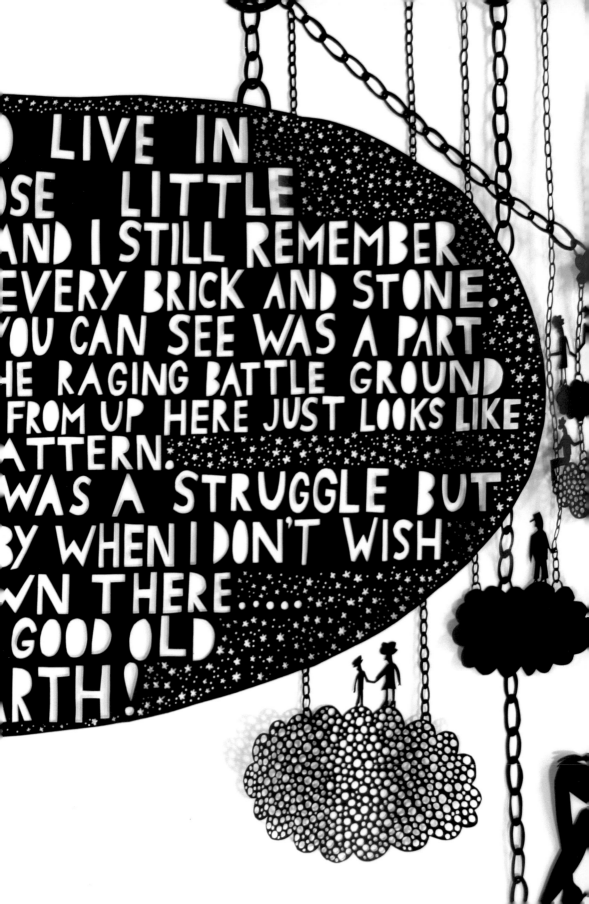

Rob Ryan

Rob Ryan creates romantic yet melancholy scenes, knifed out of single sheets of paper. Inspired by nature, his detailed landscapes feature recurring motifs – trees, birds and gently flowing rivers, which are populated with stylised figures holding hands or embracing. Ryan explains "I turned to papercutting because I liked the fact that I didn't need paint or brushes or water or oil or palettes or canvas, just a piece of paper, a knife, a pencil (and a rubber). There's no adding of paint, layer after layer – no more never quite knowing when to stop. Only taking away and taking away, first of all, all of the holes from the middle of all of the doughnuts in the world, and then the tiny slivery gaps that exist in the spaces in some lovers' entwined fingers, or maybe that tiny little island of nothingness that lives between two pairs of kissing lips. And then a bigger hole that really is the entire sky, and so on and on until all the gaps fill up and slowly become the solidness that is the world we live in that somehow lies between."[1]

Text and imagery are entwined, with stories and poetic phrases adding humour or poignancy, which highlights the importance of language for Ryan. In relation to his monumental new commission for *The First Cut*, Ryan explains "I wanted to create a much larger papercut piece to enable me to weave a longer, more continuous narrative across something in which you could see the entire piece at once."[2]

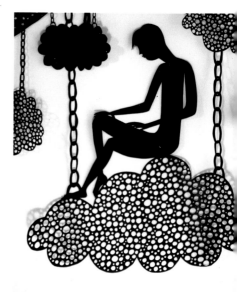

The Map of My Entire Life (detail) 2012
Framed paper cut
Photo: Liberty Wright

1 Rob Ryan in an email to Fiona Corridan 09/08/2012.
2 Rob Ryan in an email to Fiona Corridan 21/02/2012.

←
The Map of My Entire Life (detail) 2012
Framed paper cut
Photo: Liberty Wright

Rob Ryan was born in 1962 in Cyprus and studied Printmaking at the Royal College of Art, London. Recent exhibitions include *The Stars Shine All Day Too*, Air Gallery, London, *Your job is to take this world apart and put it back together again…. but even better!*, The Shire Hall Gallery, Stafford and an exhibition at Charleston, East Sussex. Ryan has also produced a series of books, including *This Is For You, A Sky Full of Kindness* and *The Gift* (written by Poet Laureate, Carol Ann Duffy) and collaborated with Paul Smith, Liberty, Fortnum and Mason and Vogue.

Andrew Singleton

Andrew Singleton's work is an exploration of the natural and manmade world through paper cutting, paper sculpture and hand drawn illustrations. His intricately cut swirling patterns recall the natural forms and structures of Art Nouveau. For *The First Cut*, Singleton captures the energy, movement and beauty of cloud formations and cosmic nebula through a combination of detailed paper cut patterns and suspended paper forms, which are connected together to achieve a sense of rhythm, movement and space.

He says "I'm inspired by the intricate, mysterious and vastly complex nature of the universe. Through imagery produced by the hubble space telescope, we are able to see deeper into space than ever before. Beaming back photographs of gigantic nebulas hanging in space remind us of where our own sun was born billions of years ago. These beautiful sculptural forms, appear to be suspended in time, but are actually places of massive activity, where huge amounts of energy cause dense gas to collapse under gravity and pressure."[1]

Singleton's process begins with studying photographic imagery for inspiration and generating ideas through sketching. This sketching develops the visual concept and also how the work will be installed in the space. He hand cuts, scores and folds the paper into both two and three dimensional pieces. This hands-on process and exploration of paper as material is when the artist begins to realise his original concept into crafted forms. These multiple components are then pieced together in situ to compose an organic, dynamic work of art.

1 Andrew Singleton in an email to Fiona Corridan 16/08/2011.

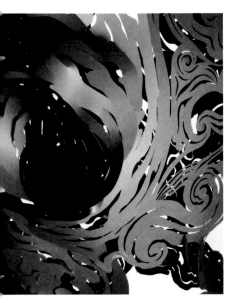

Stellar Spire in the Eagle Nebula (detail) 2012
Cut paper sculpture
Courtesy the artist

Born in Nottingham in 1983, Andy Singleton is based in Wakefield, England. He studied Animation with Illustration at Manchester Metropolitan University. Singleton has been commissioned to create installations for the Crafts Council and Liberty; Hermès; The Hepworth, Wakefield; Yorkshire Sculpture Park; Oriel Mostyn Gallery, Llandudno and Kensington Palace, London.

→
Stellar Spire in the Eagle Nebula (details) 2012
Cut paper sculpture
Courtesy the artist

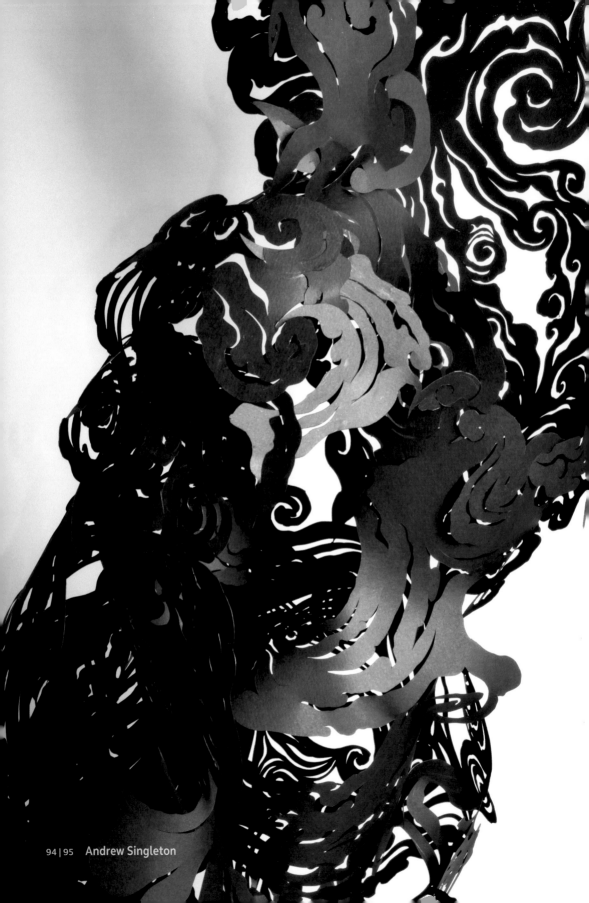

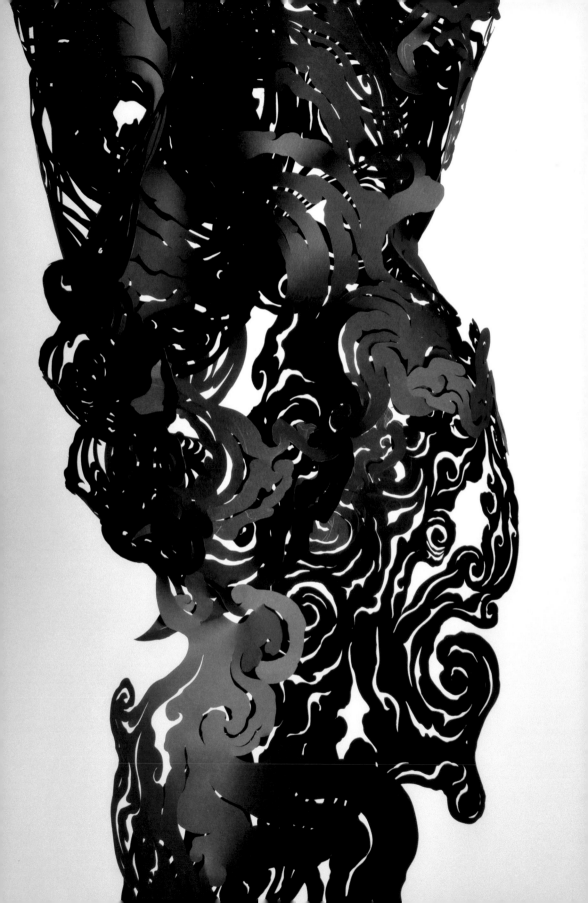

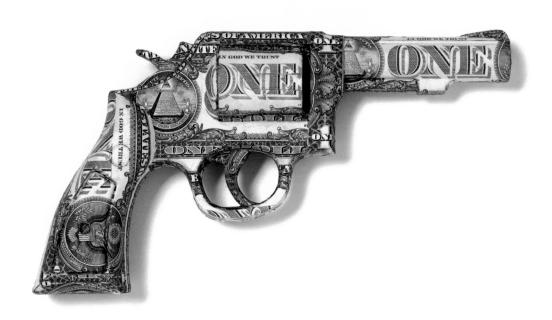

Justine Smith

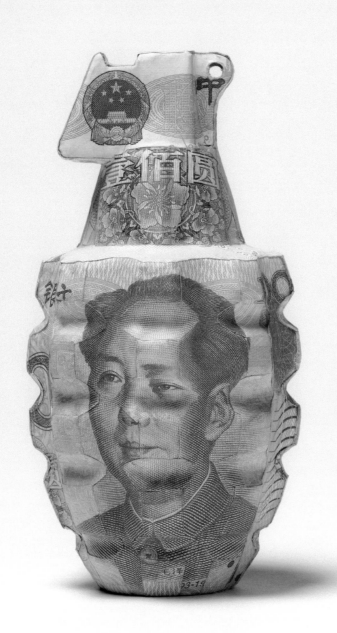

Justine Smith

Justine Smith works with printed paper, firstly comics early on in her career, then plain paper and more recently, bank notes. She sources pristine, current issue notes from all over the world in varying denominations. In the cutting of the notes, she is careful to include the most interesting parts, such as the head of Mao Zedong or the wildlife on some of the African notes and she exploits their complex colours and unique texture. Through her collages, prints and sculptures she examines what bank notes represent, the concept of money as a value system and how it becomes a route to power.

Money Map of the World 2005 portrays all the countries in the globe collaged from their own bank notes, a work which took seven months to complete, such was it's intricacy. *The Judge* 2011, a gun made from US dollars and *Inheritance* 2012, a grenade fashioned from Chinese 100 Yuan notes, make explicit the link between money, war and the wielding of political power. These sculptures appear to be solid, but are in fact hollow, made from only two layers of notes, and so in fact are very fragile, emphasising the illusory, shifting nature of power. The endangered snowdrop, captured as a specimen in a bell jar, is the focus of *The Calculation of Loss* 2009 (p. 8). Created using British Pound notes[1] issued in the 1970s, a time when the UK was experiencing recession and known as the sick man of Europe, Smith says that the work "comments on the declining power and influence of post empire Britain."[2]

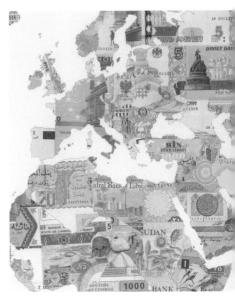

Money Map of the World (detail) 2005
Bank notes on paper
Courtesy the artist

1 The Pound note was withdrawn from circulation in 1988.
2 Justine Smith in an email to Natasha Howes 02/08/12.

←
The Judge 2011
US Dollars, perspex case
Courtesy the artist

Inheritance 2012
US Dollars, perspex case
Courtesy the artist

Justine Smith was born in 1971 in Somerset, UK and lives and works in London. She studied at the City and Guilds of London Art School. She has had solo exhibitions in London, New York and Miami and participated in numerous international group shows including at the KunstBuro, Berlin, the Pataka Museum of Arts & Cultures, New Zealand and the Pitt Rivers Museum, Oxford. Her work is held in numerous private collections and in the public collections of The British Museum, The British Library, The British Council and The Government Art Collection.

Susan Stockwell

Susan Stockwell transforms everyday materials, the ephemeral material culture present in our daily lives. She is concerned with issues of ecology, geo-politics, mapping, trade and global commerce. Paper sculptures with their delicate, disposal and fragile nature, are an important element of her practice.

Stockwell's series of dresses fashioned from maps, money, rice paper and coffee filters, use paper which has had a significant past use and history. *Highland Dress* 2010 has been created from Ordnance Survey maps of the Scottish Highlands referencing the English occupation of Scotland for over 300 years. The juxtaposition of military maps with a woman's dress sends a powerful message of the gendered nature of war and politics being traditionally dominated by men. *Colonial Dress* 2008, made from world maps, with its bustle, collar, ruffs and rose detail, immediately transports us to an age of Empire and Britain's Imperial past. Colourful bank notes from all over the world are stitched together to form *Money Dress* 2010, based on the floor length and puff sleeved style of dress worn in the 1870s by British female explorers. Sited in the historic galleries at Manchester Art Gallery and the Gallery of Costume, Platt Hall, the dresses are in dialogue with the collection and architecture, cementing their relationship with history.

Money Dress (detail) 2010
Paper money notes, cotton thread, frame
Courtesy the artist

Susan Stockwell was born in 1962 and lives and works in London. Stockwell originates from Manchester and studied at the Royal College of Art, London. She has exhibited in galleries and museums all over the world, including the V&A, London and The National Museum of China, Beijing. She has been awarded scholarships, grants and commissions such as a *Visiting Arts* Taiwan-England Artists Fellowship, an Arts and Humanities Research Council Grant and has recently completed a large public commission for the University of Bedfordshire. She has taken part in residencies and projects in Europe, America, Australia and Asia.

→
Highland Dress 2010
Paper maps
Courtesy the artist

Colonial Dress (detail) 2008
Maps, wire, glue
Courtesy the artist

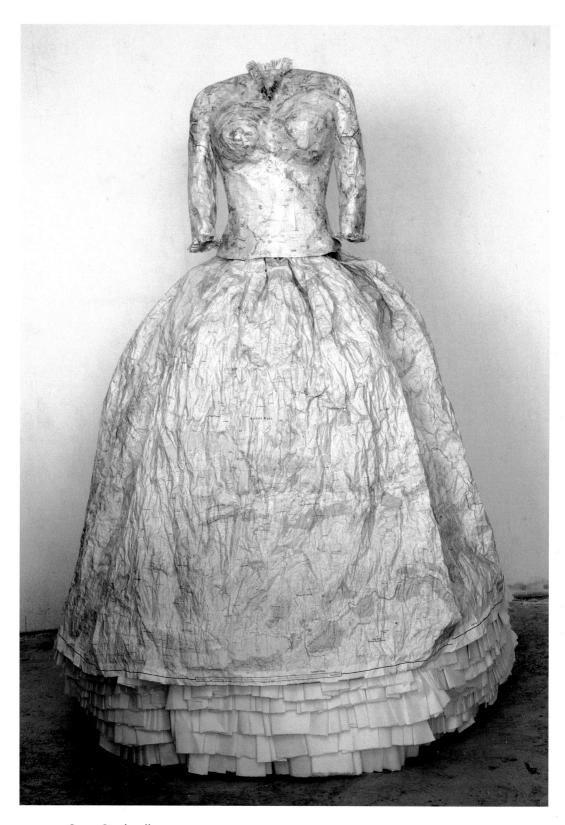

Susan Stockwell

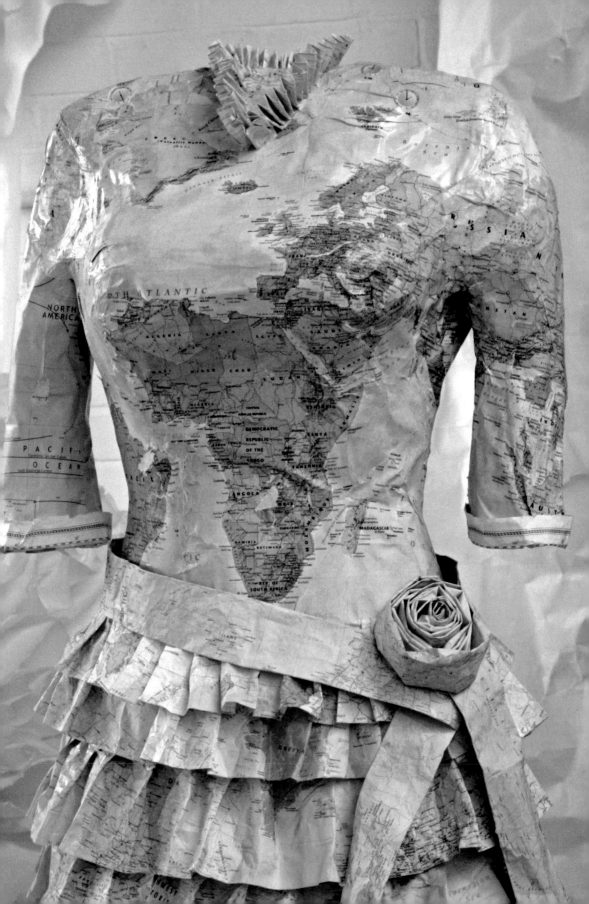

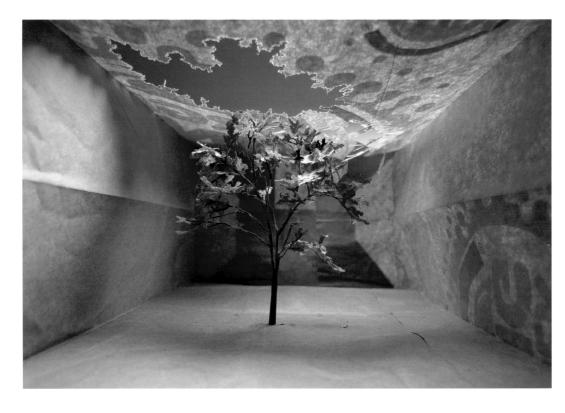

Yuken Teruya

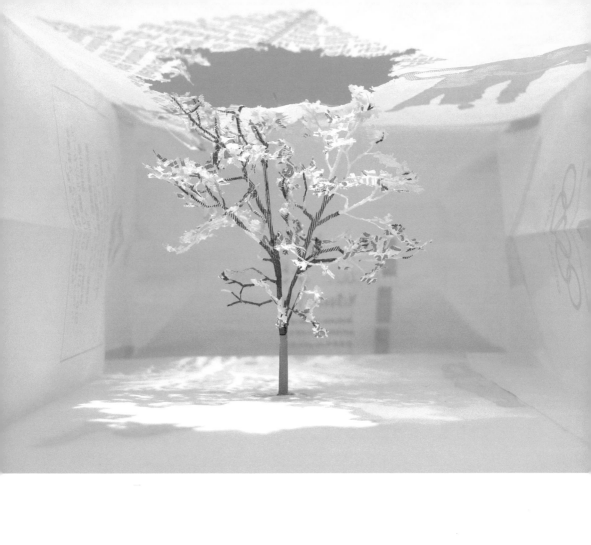

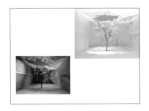

Yuken Teruya

Yuken Teruya works with a range of disposable materials including paper shopping bags, newspapers and butterfly chrysalises, as well as currency and books. His ideas often reflect the life and history of Okinawa, his homeland, but he also creates works which offer a subtle observation of globalisation, consumerism and man's impact on the environment. Teruya's intricate works have been described as "an elegant illustration of culture in the shadow of capital."[1]

For his *Notice-Forest* series, Teruya creates delicate dioramas featuring minutely detailed trees cut from paper bags. He chooses companies at divergent ends of the consumer spectrum, including LVMH[2] and Hermes right through to fast food packaging, such as *Notice- Forest (McDonald's)* 2000. Starting with a photograph of a particular tree, he incises the outline into the paper and often chooses a species native to the country of the shop or restaurant. These subtle, yet powerful works highlight the influence of brands on our daily lives, questioning the developed world's obsession with consumerism and the resulting impact on the global environment. Teruya has said of this series "when these items (paper bags) become artworks, they also easily become political, maybe because they are taken from daily life. Without criticising the present, I prefer to find new clues to problems that are likely to polarise."[3]

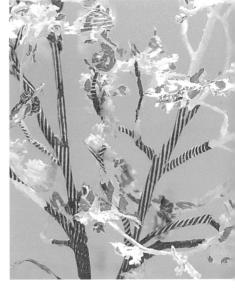

Notice-Forest: Madison Avenue (from a set of 6 McDonald's bags) (detail) 2011
Cut paper bag
Courtesy the artist

1 Megan Ratner in a review of Teruya's work at Josée Bienvenu Gallery, New York, from Frieze, Issue 96 January-February 2006.
2 Moët Hennessy • Louis Vuitton.
3 Yuken Teruya, 18th Biennale of Sydney, 27 June – 16 September 2012, www.bos.18.com/artist?id=112 [accessed August 2012].

←
Notice-Forest (Burger King) 2009
Cut paper bag
Private Collection, London
Courtesy Pippy Houldsworth Gallery, London

Notice-Forest: Madison Avenue (from a set of 6 McDonald's bags) 2011
Cut paper bag
Courtesy the artist

Yuken Teruya was born 1973 in Okinawa, Japan and lives and works in New York. He has had solo shows at Josee Bienvenu Gallery, New York; Shoshana Wayne Gallery, Santa Monica; Murata and Friends Gallery, Berlin and The Ueno Royal Art Museum, Tokyo and a forthcoming one at Pippy Houldsworth Gallery, London, 2013. Selected group exhibitions include *All Our Relations: 18th Biennale of Sydney*, 2012, *Rewriting Worlds: 4th Moscow Biennale*, Russia, 2011; *Shapes of Space*, Guggenheim Museum New York, 2007; *Greater New York*, MoMA PS1, New York, and *Yokohama Triennale* Yokohama, Japan, 2005. His works are in numerous public collections including The Guggenheim Museum and MoMA, New York; Saatchi Collection, London and Mori Museum, Tokyo.

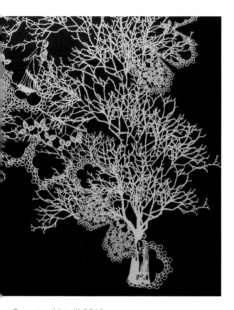

Perpetua (detail) 2010
Hand cut archival paper mounted between
perspex
Courtesy the artist and John Buckley Gallery

Emma van Leest

Emma van Leest creates incredibly intricate, visually complex imagery, which draws on a disparate range of influences. Initially inspired by the architecture and culture of European cities such as the labyrinthine streets of Venice, as well as opera and theatre sets, she created three dimensional collages that resembled Victorian dioramas. She has travelled widely to further her knowledge, studying Balinese and Javanese folk art, the ancient art of shadow puppetry in Indonesia and traditional paper cutting techniques in China. Van Leest also cites Western artists as influences including Joseph Cornell (particularly his Surrealist assemblages), the Dada collage artists and the pioneering artist and animator Lotte Reiniger. She also draws on her interest in children's literature, fairy and folk tales, as well as stories of medieval saints and Hindu literature to create her elaborate, imagined worlds.

Theodora resembles a *mandala*, a Sanskrit word for a circular form which represents wholeness and unity. Van Leest's practice has a meditative quality, with an emphasis on delicate and repetitive work, building on her interest in the artistic and devotional practice of Eastern cultures. The work blends personal mementos with elements of historical and political interest for the artist. She says of this artwork "the lace pattern is traced from a piece I inherited and the work refers to the age of exploration when Europeans colonising the globe, including Australia, were blind to the calamity and existential threat that their 'discovery' and imposition of their own values and culture had on other societies. In this respect *Theodora* is a kind of souvenir to misadventure."[1]

1 Emma van Leest in a statement to Fiona Corridan 14/08/2012.

Emma van Leest was born in 1978 and lives and works in Melbourne. She is the recipient of a number of awards to fund artistic research in Indonesia, Java and China, as well as a residency at Sanskriti Kendra, Delhi, India. She has exhibited in numerous solo and group shows throughout Australia and her work is in private collections in Australia, U.S.A., Indonesia and New Zealand.

→
Beginning always 2010
Paper, foamcore and glue
Courtesy the artist

Theodora 2011
Handcut paper
Courtesy the artist

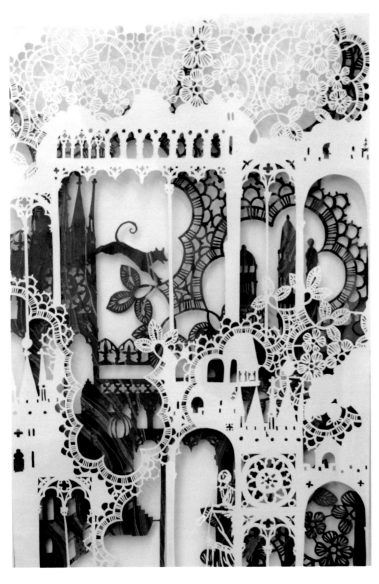

Emma van Leest

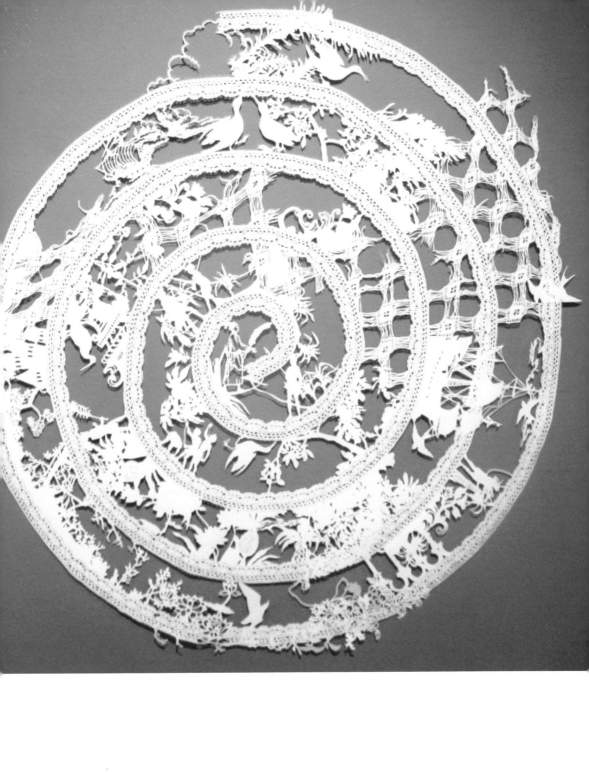

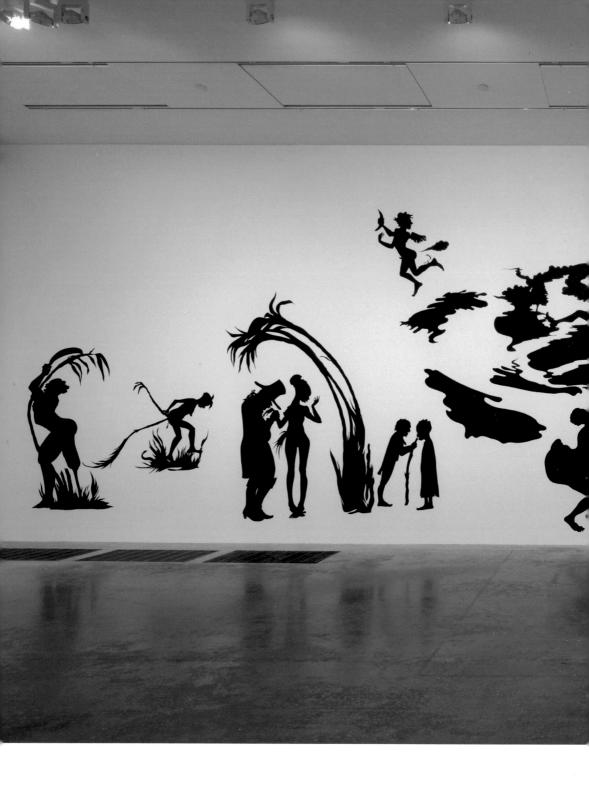

Kara Walker

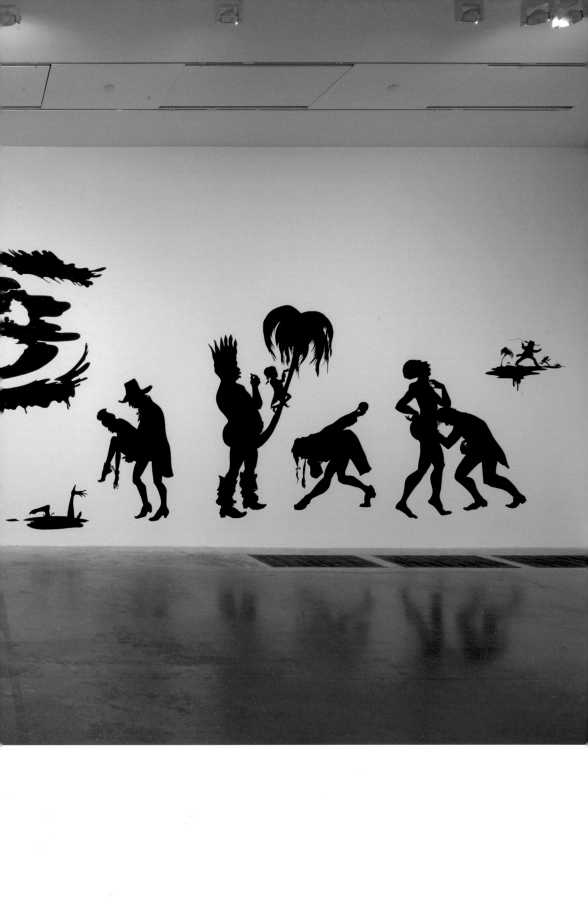

Kara Walker

Kara Walker's cut-paper silhouettes are inspired by the pre-Civil War period of the American south and re-present African-American history. Her work disarms the viewer with its provocative narratives, violence, racial stereotypes and satire. The silhouette references the 18th and 19th century tradition of white people commissioning a black profile portrait. Walker uses exaggerated features for her figures, recalling negative stereotypes of African-Americans. The narratives show acts of dominance and submission, physical and sexual violence and social and gender inequalities. Despite the cruel vignettes, there are comedic moments. Walker explains: "I use humour, but a type of humour that makes it difficult for myself or a viewer to decide just how hard to laugh. That uneasiness is an important part of the work."[1]

The large scale installation *Grub for Sharks: A Concession to the Negro Populace* 2004, was commissioned by Tate Liverpool and was inspired by the history of Liverpool and the Slave Trade. Walker's specific point of departure was J M W Turner's 1840 painting *Slavers throwing overboard the Dead and Dying – Typhoon Coming on (The Slave Ship)*, showing a slave ship which left Liverpool in the 1780s bound for Jamaica. On route, sick and dead slaves were thrown into the shark infested waters in order to claim compensation from insurance companies.[2] This practice also occurred in the event of an oncoming storm, to lighten the ship and prevent damage.

Grub for Sharks: A Concession to the Negro Populace (detail) 2004
Cut paper installation
Courtesy the artist and Sikkema Jenkins & Co.
© Tate, London 2012

1 Kara Walker interview www.indexmagazine.com/interviews/kara_walker.shtml [accessed 26 July 2012].
2 This practice was used by slave traders to claim insurance for slaves who had become weakened by the journey and could not be sold on arrival. It didn't count if slaves died a natural death.

←

Grub for Sharks: A Concession to the Negro Populace (detail)
2004
Cut paper installation
Courtesy the artist and Sikkema Jenkins & Co.
© Tate, London 2012

Kara Walker was born in Stockton, California in 1969 but spent her teenage years in the southern state of Georgia. She now lives and works in New York. She studied at the Atlanta College of Art, Georgia and the Rhode Island School of Design, Providence. She has had more than 40 solo exhibitions including at the Metropolitan Museum of Art and the Whitney Museum of American Art, New York and was selected for the 2002 Bienal de São Paulo, Brazil and the 2007 Venice Biennale. Her work features in international museum collections including Museum of Contemporary Art, Chicago, Solomon R. Guggenheim Museum, New York, and Tate, London.